D062004

DRAWING
WITH
COLOURED
PENCILS

WITHDRAWN

DRAWING

WITH
COLOURED
PENCILS

Jonathan Newey

NEW
HOLLAND

This paperback edition first publsihed in 2009
Published in 2006 by
New Holland Publishers (UK) Ltd
London • Cape Town • Sydney • Auckland

Garfield House
86–88 Edgware Road
London W2 2EA
www.newhollandpublishers.com

80 McKenzie Street
Cape Town 8001
South Africa

Unit 1, 66 Gibbes Street
Chatswood
NSW 2067
Australia

218 Lake Road
Northcote
Auckland
New Zealand

10 9 8 7 6 5 4 3 2

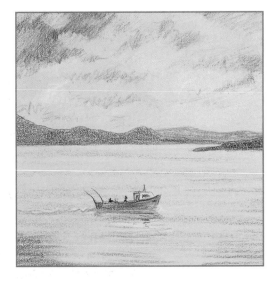

Text and drawings copyright © 2006 Jonathan Newey
Photographs copyright © 2006 New Holland Publishers (UK) Ltd
Copyright © 2006 New Holland Publishers (UK) Ltd

Jonathan Newey has asserted his moral right to be identified
as the author of this work.

All rights reserved. No part of this publication may be
reproduced, stored in a retrieval system, or transmitted in
any form or by any means, electronic, mechanical,
photocopying, recording or otherwise, without the prior
written permission of the publishers and copyright holders.

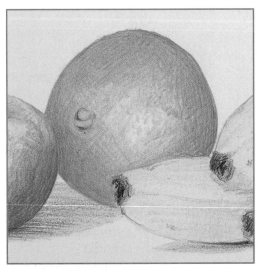

ISBN 978 1 84773 662 8

Senior Editor: Clare Hubbard
Editor: Claire Waite Brown
Design: Peter Crump
Photography: Shona Wood
Production: Hazel Kirkman
Editorial Direction: Rosemary Wilkinson

Reproduction by Pica Digital Pte Ltd, Singapore
Printed and bound in Malaysia by Times Offset (M) Sdn Bhd

Contents

Foreword

If the name Jonathan Newey is new to you, as it was to me just 18 months ago, then you are indeed fortunate to be holding this book.

My introduction to Jonathan took place in July 2003 when we met to discuss the possibility of him tutoring some painting courses at our arts centre in Castle Rising, Norfolk. Since then he has run many successful courses for us and, in that time, has given numerous beginners the confidence to make a start, and motivated an equal number of experienced artists to achieve greater things.

Jonathan's students regularly speak of his enthusiasm, not only for his own work but for what he inspires within them. Often they will remark on his cheerful readiness to demonstrate a painting or drawing technique or carefully go over a particular point as many times as is necessary to ensure everyone has fully understood.

His working knowledge of drawing and painting is vast and, as you will discover when you start using this book, very relevant to anyone looking to really get the most from a set of water-soluble coloured pencils; beginner and more experienced artist alike.

I was delighted when I was asked to write this foreword for Jonathan's first book. Not only because it is a beautifully illustrated, thoughtfully constructed source of practical information – which it most certainly is – but also because I have experienced at first hand the uncompromising level of commitment he brings to everything he does. Read this book and you will know precisely what I mean.

Richard Cartwright
West Norfolk Arts Centre

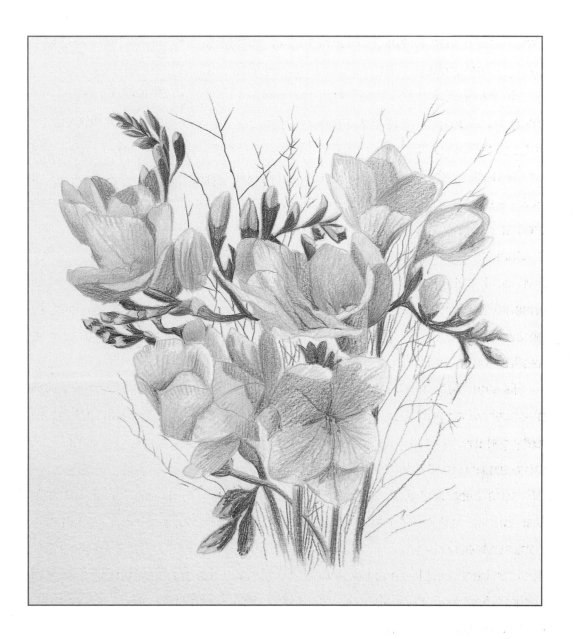

Introduction

"I didn't realize you could do that with a coloured pencil."

I have heard the above phrase used on many occasions when I have demonstrated and exhibited my pencil drawings. Even when shown what can be achieved with the coloured pencil people still do not believe it. This is a book that I hope will dispel a few of the myths, about what can and cannot be done with a coloured pencil, and also some of the mysteries surrounding drawing itself.

Drawing with a coloured pencil is no different from drawing with any other type of medium. It can be as expressive as charcoal, pastel and graphite and, as you will soon see, the subjects you can choose from are just as varied. Indeed, the only problem with coloured pencils is getting them accepted by the art world in general. Art groups and the art establishment still consider them to be merely children's crayons and not worthy of inclusion in their idea of an acceptable art form. Yet many artists worldwide consider them to be an exciting and versatile medium and an important part of their creative processes. Drama, beauty, humour, character, atmosphere and excitement are all achievable with the coloured pencil, plus of course a little imagination from the artist.

As with anything in life, especially an art medium, learning the basics of using coloured pencils and developing specific skills and styles will take a little time. This book will help you get started by giving comprehensive instructions

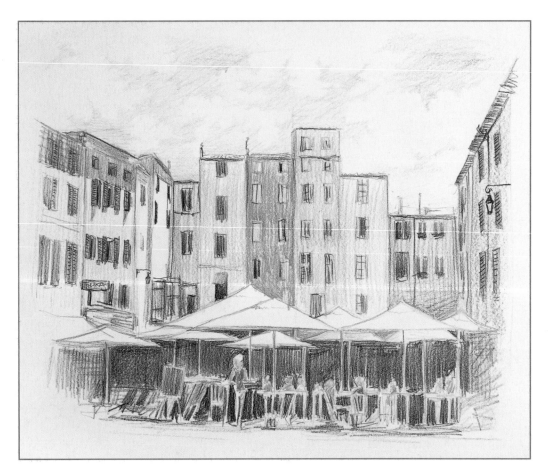

Coloured pencils can be used in a variety of interesting and exciting ways. They are particularly ideal for sketching. (See Landscape demonstration 4, pages 68–73.)

on types and uses of tools and materials and by illustrating a few basic techniques that will help you begin your first coloured pencil drawing. The demonstrations in the book are laid out in a simple, step-by-step format with clear instructions and pictures, including a list of the tools and materials required. The aim of the book is to introduce the absolute beginner to the varied techniques and subjects that can be achieved with the coloured pencil, and emphasize its ease of use and portability when sketching outdoors.

Also included are techniques on how to use water-soluble pencils as a painting medium and how to use them in combination with dry pencil techniques. There is a variety of different surfaces or 'supports' used in the demonstrations, all of which are explained in the tools and materials section of the book. To inspire your own work there is a gallery section at the end of the book featuring a variety of other artists' work, each with a brief description alongside.

I have spent many years teaching people how to draw with coloured pencils and have included a lot of my teaching techniques in the production of this book to help you get started with this wonderful drawing medium. I hope you enjoy reading the book but, most of all, enjoy the success that I anticipate the book will bring you in your use of an exciting and rewarding medium.

Softer and more delicate effects can be achieved using water-soluble pencils as a painting medium. (See Animals demonstration 3, pages 110–115.)

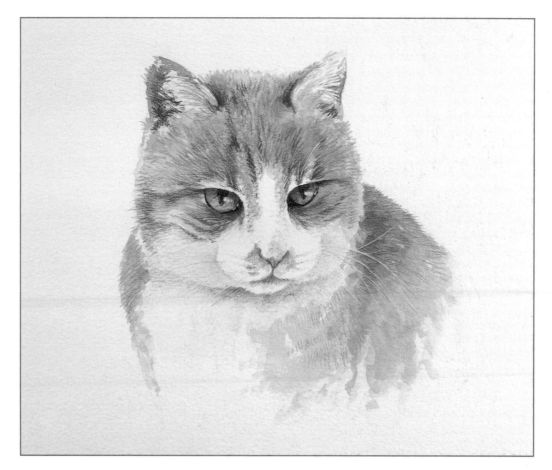

Tools and materials

All you need to begin drawing is a small collection of coloured pencils and some paper. However, there is a huge range of brands available on the market, so here is a useful introduction to what is available and what you will initially need.

Pencils

Most of the major art manufacturers produce a comprehensive range of coloured pencils, some of which run to over 100 different colours. Each particular make of pencil has its own characteristics and will produce different effects, which can also vary depending on the surface you are working on. Most of the pencils available are sold individually or in boxed sets starting with 12 to a box, and can be bought in any good art shop or by mail order from monthly art magazines or the Internet.

There are basically two different kinds of coloured pencil. First there is the standard, non-water-soluble coloured pencil that is used dry but can be dissolved using a spirit-based solvent. Then there is the water-soluble pencil. This contains a pigment that can be loosened by washing over the drawn pencil colour with a damp brush. The water-soluble pencil can be used dry, but when working dry, the non-water-soluble pencil has a slightly softer, creamier feel to it.

For the demonstrations in this book we will be using a full set of water-soluble coloured pencils; however, all you need to start with is a basic set of pencils that can be added to as you progress.

Protecting your pencils

Even though coloured pencils have a hard wooden casing they are prone to damage, especially when dropped. We have all sharpened a pencil and experienced the frustrating misfortune of having the pigment inside the wood fragment as we sharpen it, owing to the pencil having been dropped onto a hard surface. To prevent this, when using the pencils keep them close to the drawing board in a position where they can't roll off the table or be knocked off. When storing them keep them in their box or, if bought individually, in a pencil wrap or rolled up in corrugated cardboard, making sure they can't slide out of either end.

Pastel pencils

Pastel pencils are a completely different entity to coloured pencils and are not used in this book, but warrant a mention to avoid confusion. Pastel pencils are made from a chalk-based pigment and not a wax or oil base as coloured pencils are. They have a similar feel to artists' soft pastels and, therefore, are used in a different way and with different results to the coloured pencil.

Papers and boards

Once again, there is a huge range of different surfaces that you can apply coloured pencils to. It is best to stick with the papers and boards, or what artists refer to as 'supports', that are specifically designed for the fine-art industry. This is because they have had the acidic levels strictly controlled during the manufacturing process to prevent yellowing of the surface with age. Do not use the cheapest paper you can find. The last thing you want is for the masterpiece you spent hours on to turn yellow in 12 months.

If you are going to work on a white surface, a good basic paper to start with is cartridge (drawing) paper. This is available in a variety of weights – which refer to the thickness of the paper – and the whiteness of the paper can vary according to the manufacturer. Some

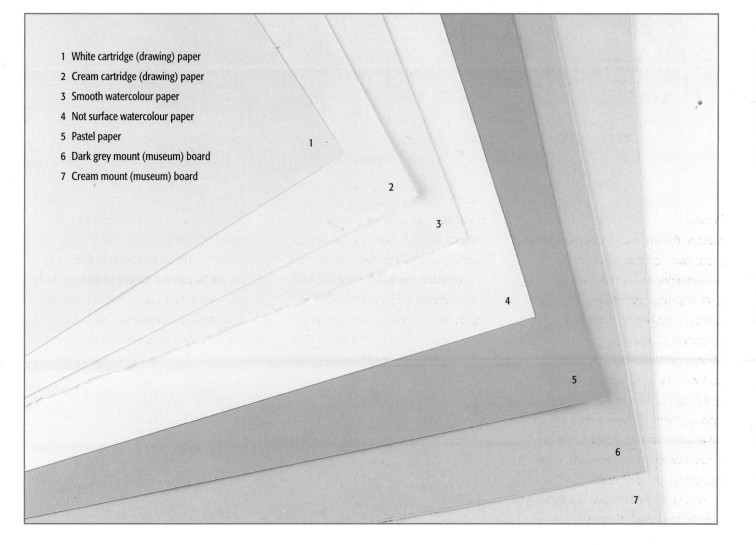

1 White cartridge (drawing) paper
2 Cream cartridge (drawing) paper
3 Smooth watercolour paper
4 Not surface watercolour paper
5 Pastel paper
6 Dark grey mount (museum) board
7 Cream mount (museum) board

Tools and materials

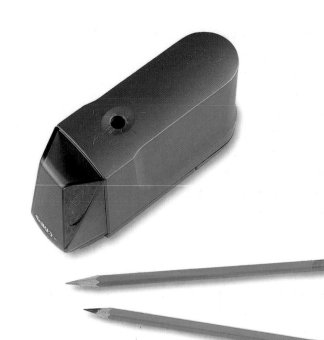

cartridge (drawing) paper can also have a slight texture, or what is commonly called the 'tooth'. Try out different types to see which suits you best. Another alternative, which is slightly more expensive, is watercolour paper. Again, this is found in different weights, different textures and even tinted with different colours. For a textured watercolour paper use either 'not' or 'rough'. I recommend using the not surface, sometimes called 'cold pressed', especially if using water-soluble pencils wet, and choosing a 300gsm (140lb) thickness to prevent 'cockling' or wrinkling of the paper when wet. For a smooth surface, use 'HP' or 'hot pressed' paper. A smooth watercolour paper is whiter and smoother than cartridge (drawing) paper.

For a coloured background you can use pastel paper, which is available in a wide variety of colours. However, it does have a slight texture to it that can make it hard to work on if the coloured pencil is not soft enough to fill in the texture. 'Mount' or 'museum' board makes a good alternative. This is a board normally used in framing works of art on paper. It not only gives a coloured surround to the picture, but also keeps the glass from touching the surface. It is available in a variety of colours, some incredibly strong, and because it is used in the framing industry it has a very low acid content – or in some cases is completely acid free – so will not yellow with age. The surface is invariably smooth and can take many layers of colour and a lot of scraping and rubbing out, although it is not advisable to use the pencils wet because this may lift the top layer off the board. If you want to experiment with board ask your local framers for any offcuts that they no longer need.

Sharpeners

Having a good pencil sharpener is essential when working with coloured pencils. I use a battery-operated pencil sharpener that gives an incredibly fine point and is very easy to use – although it does have a tendency to eat pencils rapidly if you are not careful. The usual metal, handheld sharpeners are still a favourite with a lot of people. They can become blunt if used frequently, but some can be bought with replacement blades. One thing to remember when purchasing any kind of pencil sharpener is that some pencils are slightly fatter than others, so take one pencil with you to make sure that it fits the hole in the sharpener.

The traditional way of sharpening a pencil is to use a craft knife or scalpel. This can achieve a good, strong, fine point but the technique takes a bit of

practice. Taking the blades on and off a knife can be a bit fiddly and you must be careful to avoid cutting your fingers.

One handy piece of equipment is a piece of fine sandpaper or glass-paper stuck to a square of cardboard (see right). Use this to sand a fine point onto a pencil rather than using the pencil sharpener every time, which can eat the pencil rather quickly. An emery board used for filing nails can also be used.

Erasers

Two main types of eraser are commonly used. The first is a kneadable putty eraser. This is a very soft and sometimes sticky eraser, which can be moulded into fine points or straight edges and will lift off light areas of colour, although because of its softness will not lift off very heavy pigment. Dabbing the eraser over the colour rather than rubbing can also achieve certain effects. For rubbing out or lifting off heavier areas of pigment, use a white plastic eraser. This is much harder than the putty eraser and can be sculpted with a craft knife or scalpel to achieve either a straight edge or a fine point.

For areas where too much colour has been put down you can use a battery-operated eraser. This has interchangeable eraser points, which can also be sharpened with a knife; however, if you do this a lot it will wear out the eraser point very quickly.

Another method of removing excessive pigment is to use a scalpel to gently scratch the pigment from the surface of the support, although it is best to only use this method as a last resort and only if working on board since it can cause damage, especially to paper.

Whatever eraser you use, remember

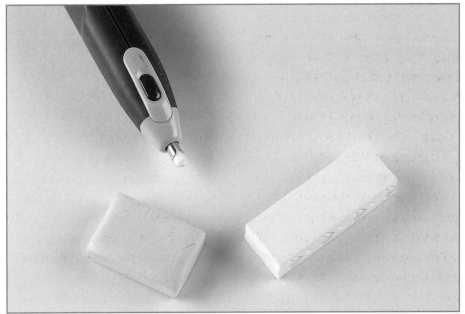

to make sure it is clean before use, because any colour left from the previous rubbing could be transferred to your drawing. Another point to remember about using an eraser is that excessive rubbing, especially on thin, delicate paper such as watercolour paper, will damage the surface you are working on. So try not to rub too hard.

Tools and materials

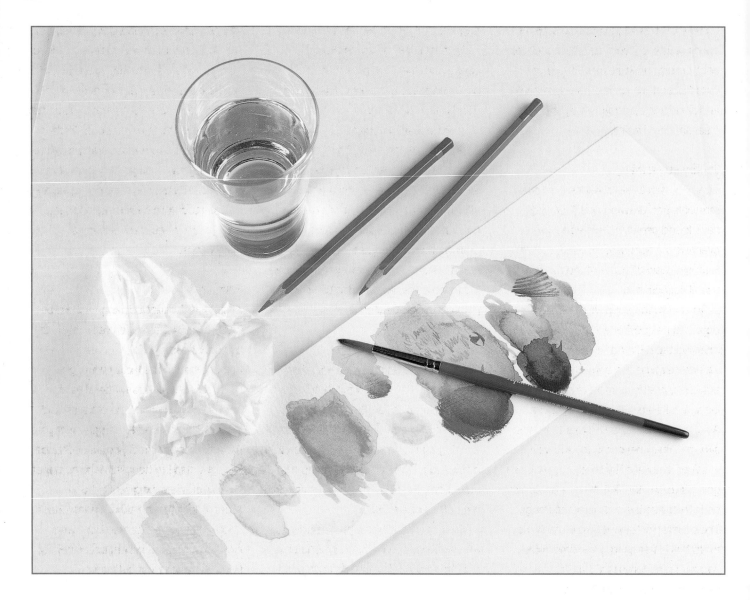

Brushes

To dissolve the pigment contained in water-soluble pencils you should use a fairly soft watercolour brush. These are available in a variety of sizes and styles that you can choose depending on what your budget will stretch to. A size 4 or 6 round sable or sable/synthetic blend watercolour brush is a useful purchase and is the ideal size to work with on the water-soluble demonstrations in this book. Wash the brush out thoroughly after use and store it away from the pencils; if it comes into contact with one while still damp it may stick to it.

Drawing boards

Just as important as the materials you work with is your working environment, especially the board you use as a support. A wooden board that is at least 6mm (¼in) thick and about 45mm (2in) larger all round than the paper you are working on makes an ideal drawing board. The board can be slightly propped up on any tabletop by positioning a couple of books underneath the top edge, or used in conjunction with a tabletop easel. If you are working on fairly thin paper place a few sheets of newspaper in between the paper and the drawing board so that the pencil shading does not pick up any scratches or imperfections in the surface of the drawing board.

Solvents

For the demonstrations concerning wet pencil work we will be using water-soluble pencils in conjunction with water. Ordinary tap water is sufficient, although it is advisable to change the water regularly since the pencil pigment can be extremely strong and will stain the picture if the water is dirty. Artists who only use the non-water-soluble pencils sometimes

use a spirit-based solvent to dissolve the pencil pigment. They use either a white spirit or turpentine solvent, or a product called Zest-it, which is a non-flammable and non-toxic alternative and has a pleasant citrus smell.

Sundry accessories

Over time artists will collect extra tools, materials and drawing aids that they have found useful in their work. To list everything would be confusing, so here is an overview of some of the most useful accessories.

To secure the support to the drawing board use a good quality, low-tack masking tape. Do not use a cheap version because the chemicals in the adhesive, if left stuck to the paper, will leave a yellow residue on the picture. Also, a cheaper tape can tear the paper surface when you come to remove it.

When you have decided what you're going to draw, the first thing you need to do is to create the outline of the image. The purists will tell you that the only way to do this is freehand. However, unless you are an accomplished artist, you will probably end up using the eraser so much that it damages the surface you want to work on. So, a good method is to trace down, a technique described in detail in the Basic techniques section (see page 22). To do this you can use any readily available tracing paper. Tracedown paper, a very thin paper impregnated with graphite on one side, can also be used; however this product is quite expensive and in some cases difficult to get hold of – it is also relatively easy to make your own by rubbing graphite pencil onto one side of tracing paper. Other products that can help you transfer your outline accurately include

projectors, light-boxes and a camera lucida that uses mirrors to project a scene onto the drawing surface; however, these can be expensive and not all art shops stock them.

Another useful addition to your tool collection is a soft cloth. This can be used to gently brush off any eraser residue that may collect on the drawing after rubbing out, or it can be used to cover part of the drawing to stop your drawing hand smudging the work while you work on another part of the picture. Household tissues can also be useful for protecting work and for blotting wet pigment washes.

Every time a pencil is sharpened it, obviously, gets shorter, and will eventually be so short that it is difficult to hold. Pencil extenders can be used to hold a stub of pencil so that you can continue working comfortably. Again, these can be difficult to find but a good art shop or mail-order company should be able to get hold of one for you.

After spending hours producing your masterpiece, you will need to protect it prior to having it framed. You can use

tracing paper as a temporary cover, but a more permanent way to protect it is to use a fixative. This comes, generally, in an aerosol and, if used correctly, will protect your work from harmful ultraviolet rays. Some artists prefer not to fix their work because some fixatives can dull the colour slightly, but if you use one of the better-quality fixatives and do not spray on too much this should not happen. Always follow the manufacturer's instructions.

Framing

All coloured-pencil drawings should be framed under glass and preferably with glass that has a UV filter coating to prevent the picture fading with age. A good framing shop will be able to advise you on which type of frame and mount you will need to complement your picture. Once framed, you must choose the right place to hang it. Make sure that it is out of any strong sunlight and fluorescent light and do not hang over a strong heat source or in a room with extreme variations in heat and humidity, such as a kitchen or bathroom.

Basic techniques

The following basic techniques are used in the demonstrations in this book. They will introduce you to the skills and techniques that I have developed over the years and are designed to give you a head start in your own drawings. However, you will find, with practice, that you discover your own ways of doing things that will make your drawings unique. The following exercises are done on white cartridge (drawing) paper unless otherwise stated.

Holding the pencil (Fig. 1)

The way you hold a pencil will determine the line that the pencil produces. Hold the pencil vertically, at 90 degrees to the paper, to produce a very thin, sharp line (top). Hold the pencil almost horizontally to give a thicker, softer line (bottom). Therefore, if you wish to shade in a large area without showing too many pencil lines use the side of the exposed pigment by holding the pencil almost horizontally. Remember, the sharper the pencil, the sharper the line.

Shading a single colour (Fig. 2)

The strength of the colour on the paper depends on the amount of pressure you apply with the pencil. The more pressure, the stronger the colour. Try this for an exercise. Using a fairly dark colour, such as a blue, start shading an area approximately 2cm (1in) wide, applying as much pressure as you can without breaking the point. As you move down the paper start to release the pressure on the pencil until you end up with a light shaded area at the end of the exercise.

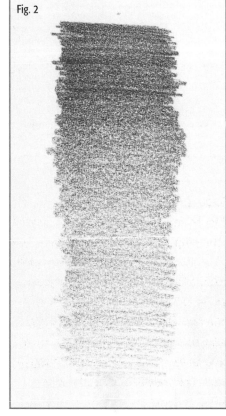

Fig. 2

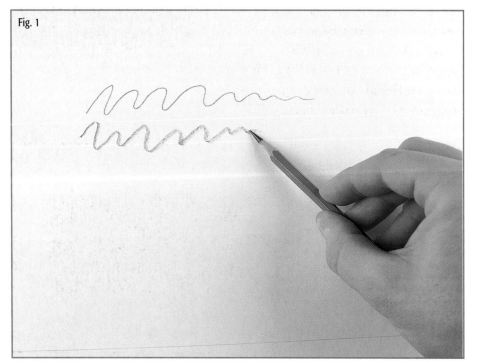

Fig. 1

■ TIP

You may find it easier to turn the paper so that you are shading at a 45-degree angle, or to adjust the angle of the paper to the position that you feel is the most comfortable.

Shading in flat layers (Fig. 3)

Another way of shading with a single colour is to do so in consecutive layers. This is also a good way of shading without too many pencil lines showing. Start by lightly shading four areas approximately 2cm (1in) square each, in a row across the paper, and number them from left to right (1, 2, 3 and 4). Turn the paper through 90 degrees and shade over squares 2, 3 and 4, applying the same colour with the same pressure. Turn the paper again and shade squares 3 and 4. Finish by turning the paper once more and shading a final layer over square 4 only. You should end up with four shaded squares, each increasing in strength as a result of the layers that have been put down.

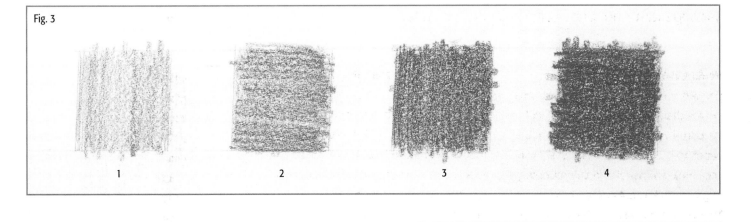

Fig. 3

1 2 3 4

Colour blending (Fig. 4)

Despite some of the larger sets of pencils containing over 100 different colours, you will, at some stage, need to mix or blend colours together to achieve a particular shade or hue. To do this choose two different colours, such as a blue and a yellow. Starting with the yellow, make a graduated tint, as you did for Shading a single colour (left), starting strong and releasing the pressure on the pencil as you move across the paper. Next, turn the paper through 180 degrees and do the same with the blue, overlapping the yellow in the middle as you release the pressure on the pencil. Repeat these two steps a few times and you will find that you have created a green colour in the middle where the yellow and blue overlap. Try this a few times with different colours, such as red and yellow, light blue and red or light red and green.

■ TIP

After using a light colour with a dark colour, the lighter pencil will have been contaminated with the darker colour. To clean the pencil either rub your finger over the end or lightly rub the pencil on a piece of scrap paper.

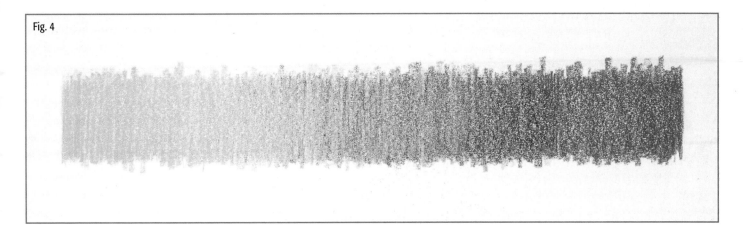

Fig. 4

Basic techniques

Burnishing (Fig. 5)

The thin line of a pencil is ideal for making rough textures and depicting fur and hair. There will be times, however, when you don't want the line of a pencil to show in the finished drawing; for example when recreating highly polished surfaces or when drawing the smooth hide of an animal such as an elephant or tortoise. This is when the burnishing technique is particularly useful. This method is best carried out on a fairly rigid support, such as mount (museum) board, but for this particular exercise you can do it on a white cartridge (drawing) or smooth watercolour paper. Starting with a dark colour, lay down a fairly strong, even area approximately 2cm (1in) deep by 4cm (2in) wide, using even pencil strokes that are not too individually heavy, because even the burnishing will not get rid of very heavy pencils lines. Start 'burnishing' the dark colour by rubbing a white coloured pencil over the top and in the same direction as the dark colour. The white pencil will start to soften and slightly lighten the dark colour underneath and give it a burnished look. When you have done this, turn the paper so that the next layers are at 90 degrees to the first layer and repeat the process of dark then white, but not so heavily this time. What you should end up with is a block of colour that has a deeper intensity and a slightly shinier feel to it.

One of the problems with burnishing is that you put down a lot of colour. If you are using cheap pencils you will probably find that, at some stage, the pencil will start to 'skid off' the paper or board because of the high wax content in the pencil. It is therefore advisable to only use artist-quality pencils for burnishing.

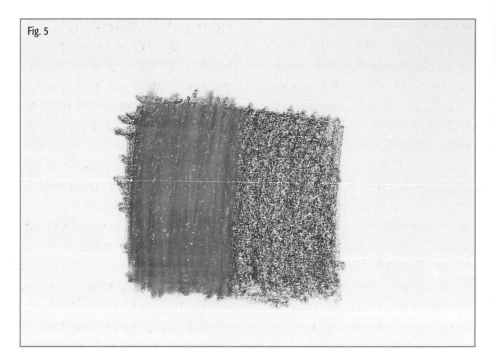

Fig. 5

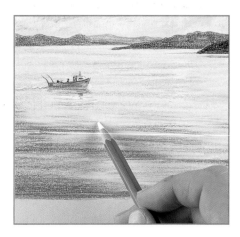

Darker colours can be softened and blended together using the burnishing technique, which is particularly useful when drawing flat water. (See Landscape demonstration 2, pages 56–61.)

■ TIP

Try using different supports, the smoother the better, and, as mentioned earlier, for the best results use a rigid support. You can also try using different light coloured pencils such as yellows or light blues. These will produce the same result as the white but will give the finished work a tint of whichever colour you have used.

Coloured supports

Some of the pictures and demonstrations in this book have been carried out on coloured papers or boards. Coloured supports will have a huge influence on the finished look of a drawing, so it is a good idea to experiment with cheap coloured paper or offcuts of coloured mount (museum) board from your local framers. Complete the exercises and demonstrations using as many different coloured supports as possible. You do not have to do the complete demonstration and as you are doing the exercises make notes of the coloured pencils you use so that you have something to refer to later.

Rubbing out and lifting off (Fig. 6)

Erasers and knives are useful tools for removing unwanted colour or correcting mistakes. They can also be used as an aid to drawing and to produce particular textures and effects. A soft putty eraser, for instance, can be used for very subtle effects on light colour. Try dabbing an area of colour with the putty eraser to see how much colour can be lifted. By squeezing the eraser edge you can also erase a faint line through a body of colour. With a hard plastic eraser you can achieve harder lines in heavier colour. Try cutting off a piece of eraser with a knife to reveal a sharp edge and use this to drag through the colour. Depending on the amount of colour and how dark it is you may have to drag the eraser a few times to achieve the desired effect. If you have laid down too much colour, or you wish to lighten a dark colour in a particular place, you can use a knife to scrape off some of the colour from the surface. Start by laying down a very dark colour using the Shading in flat layers technique (see page 17). Get as much colour down as you can. Using a craft knife or scalpel, start to scrape away some of the colour, being careful not to damage the paper. Use the flat part of the blade, not the point, or for best results try using a scalpel with a curved blade. You will not scrape off the entire colour but, used in conjunction with the plastic eraser, you will be able to remove a significant amount.

■ TIP

Use the knife in one direction only. Scraping vigorously in both directions will increase the chances of damaging the support.

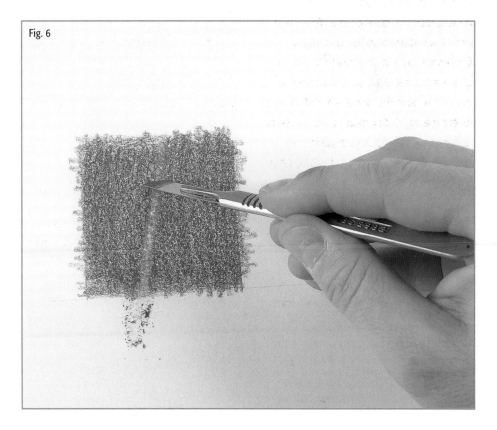

Fig. 6

Basic techniques

Adding thin highlights (Fig. 7)

There may be some instances where you need to add thin, light areas in your drawing, such as for highlights or whiskers. One simple way to do this is by using the point of a sharp knife to scratch a line into the picture. You will need to do this towards the end of the work because it will probably damage the paper underneath.

You can also achieve light or white areas by painting them in with white paint or by using the pigment from a white water-soluble pencil. Lay down a small area of concentrated white pigment from a water-soluble pencil on a piece of scrap paper and use a damp brush to loosen the pigment. Pick up some of this wet pigment on a small brush and paint the thin white line into the drawing. Alternatively, if you only need a small amount of white pigment you can use the wet brush to pick it up directly from the end of the pencil.

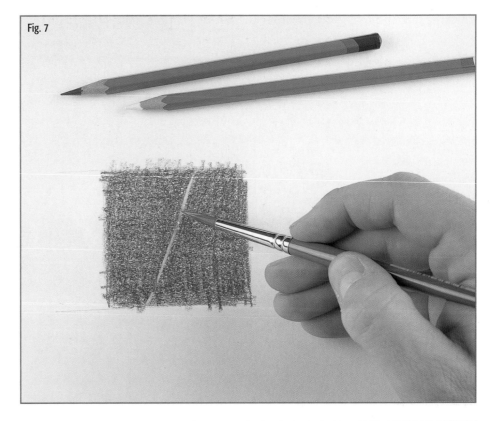

Fig. 7

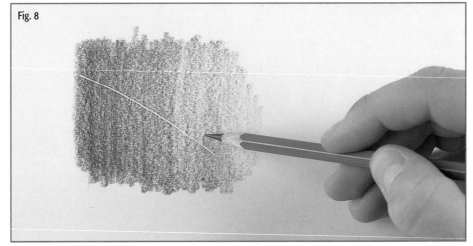

Fig. 8

■ TIP

If you have laid down the underlying dark colour using water-soluble pencils take care when applying the wet white colour on top, because you don't want to wet the dark colour and inadvertently mix this in with the white.

Incising thin highlights (Fig. 8)

Another method you can use to achieve a thin white line is to incise a groove into the paper or board prior to applying any colour. Use your fingernail or the back edge of a knife to make the groove in the surface then apply the colour over the top by shading at 90 degrees to the groove.

■ TIP

You might want to practise incising the line on some scrap paper to ensure you are happy with its position and length before committing to the working paper, because once it is incised into the surface you can't rub it out.

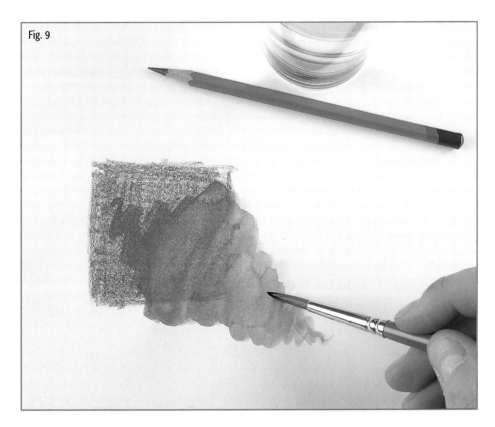

Fig. 9

Dissolving colour with water (Figs 9 and 10)

There are a number of ways of using water-soluble pencils in conjunction with water. The basic method is to apply the colour to the paper and wash over it with a damp brush (see Fig. 9). One thing that becomes apparent is how strong some of the colours are when wetted. Try this exercise using different colours to get an idea of what they look like when wet.

To achieve a small area of wet colour without the pencil marks showing, lay down the dry colour on a piece of scrap paper and pick up the colour with a damp brush (see Fig. 10). Use the scrap paper as a kind of watercolour palette, mixing wet colours together to achieve the desired colour.

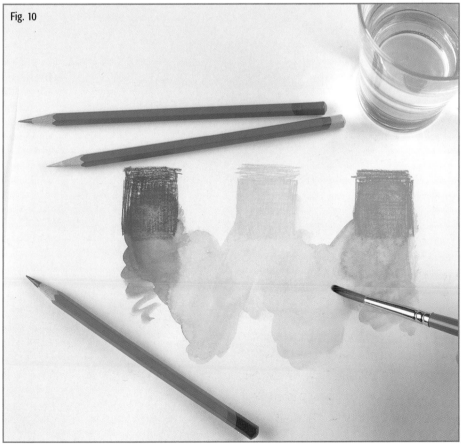

Fig. 10

■ TIP

Certain textured effects can be achieved by dropping pencil pigment shavings onto a wet area of paper. Alternatively, drop pencil pigment shavings onto dry paper and spray water directly over the top with a plant mister.

Basic techniques

Tracing down (Fig. 11)

'A good drawing never made a bad painting.' Although a touch ambiguous there is an element of truth to this saying. One of the problems of drawing with coloured pencils is that the supports can't take too much erasing, so it is a good idea to generate the outline image on a separate, thinner piece of white paper then transfer the image onto the working surface. A common method of doing this is called 'tracing down'. First select the photograph or image you are going to work from, then using either a photocopier or a computer generate a black-and-white copy to the size you require. Tape a sheet of tracing paper over the top of the image and trace the outline using an HB or 2B graphite pencil. When you are happy that you have traced everything, carefully remove the tracing from the copy and tape it onto the working surface. Choose a coloured pencil that will not show up in the finished drawing and make sure it has a good point. Holding the pencil as you would a pen, place it underneath the tracing paper and on top of the working support and trace the outline. This will feel a little awkward to begin with, but it will cut down the amount of time spent getting proportions and angles right, especially when creating portraits.

An ideal way of tracing an image is to use a projector, but these are expensive and can be difficult to get hold of unless you have access to the Internet. Some artists will rub the back of their tracing paper with a coloured pencil or graphite and then go back over the tracing with it flat on the working surface. The problem with this technique is that if you press too hard an outlined groove that cannot be removed is left in the picture.

■ TIP

Be careful when peeling the masking tape from the working surface. Take it off slowly to cut down the risk of tearing the paper.

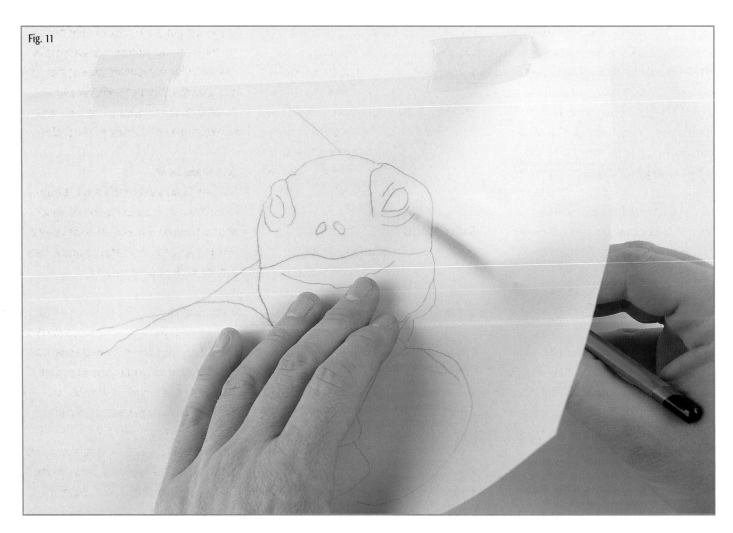

Fig. 11

Demonstrations

The following demonstrations are laid out in a simple-to-follow format and are aimed at absolute beginners – although artists with a little experience or at a more advanced level with their work will also benefit. The 16 demonstrations feature step-by-step instructions including photographs of each step that will help you successfully complete each project. These projects look at shading, texture, colour mixing and light and dark tone, and feature subjects such as sketching, fur, skin tone and shiny surfaces.

The projects are designed to help guide you through the process of learning to use a coloured pencil. The most important thing to remember is that you need to practise as much as possible. Trying one technique just once will not improve your drawing and because everybody is unique, you will not achieve the same style as I have. Aim to practise each technique as much as you can and start to vary the colour or subject matter to enable you to get used to the different effects that can be achieved with the coloured pencil. You will find, with time, that your own style will start to emerge and I hope that this section will inspire you to try your own pictures using your own reference material.

How to approach the demonstrations

Each demonstration starts with a brief introduction followed by a list of the pencils and materials required to complete it. Also included at the end of each demonstration is an alternative photograph and a description of what can be done at a more advanced level.

The materials

Each demonstration lists the make and shade of each pencil used. These are a guide only and it is not essential that you use exactly the same brand and colour. A common description of the colour is used in the main body of text during each step, such as warm yellow or light grey. If you can't find exactly the same pencil use one that closely matches the colour in the photographs. The demonstrations that use the pencils dry can be completed with any make of good-quality coloured pencil; however, for the demonstrations that use them as wet pigment you will need to purchase water-soluble pencils, which are widely available. These can also be used dry.

Additional tools and materials are also listed. Some of the items, such as sandpaper and pencil sharpeners, may not get a mention during the demonstration but will be used from time to time to maintain a sharp point on the pencil. Tracing paper is used in most of the demonstrations to trace down the outline. The method of tracing down is the same throughout and is mentioned in detail in the Basic techniques section of the book (see page 22), so this text is not repeated in individual demonstrations.

Softer pencils

Reference is made in the text to soft, white pencils. There are a huge variety of softer pencils on the market and they should be available to buy individually. The best ones to use are the non-water-soluble pencils as they tend to be softer than the watercolour variety.

The support

The particular support used for each demonstration is listed but do not worry too much if you can't find that particular support. It is more important that you practise the pencil techniques in the demonstration than be concerned about the correct surface.

Reference photograph

In each demonstration there is a short description of the photograph used. This is because you should always look carefully at the photograph you are using before you start. Indicated on some of them are aspects that need to be changed or omitted. If, once you have finished the demonstration, you want to use your own photograph then do a few small, quick sketches of the photograph to make sure that it looks right. What looks fine in a photograph may not look right in a finished drawing.

Tips

The tips supplied throughout the book are there to help with certain aspects of the particular demonstration, but they do not need to be incorporated into the drawing. You can decide if you want to include them or try them at a later date.

Technique check

After the final step in each demonstration, you will find a summary of the subject and techniques covered. This includes a basic description of the techniques used and the skills you have learnt.

A step further

At the end of each demonstration you will find a small section on a more advanced subject featuring certain elements that are connected to that demonstration. They do not have to be done straight after you have completed the demonstration, and you might even want to finish the other demonstrations in the book before coming back to the more advanced subjects.

DEMONSTRATIONS

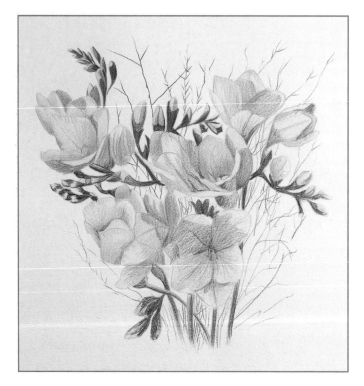

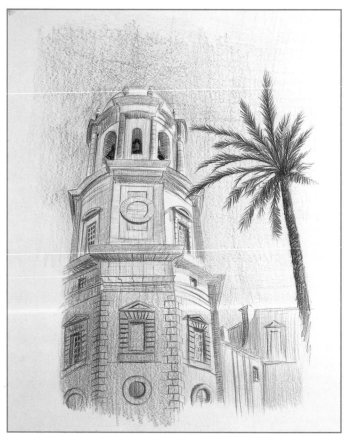

PEOPLE

ANIMALS

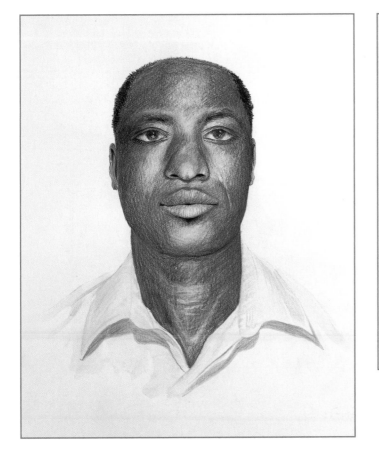

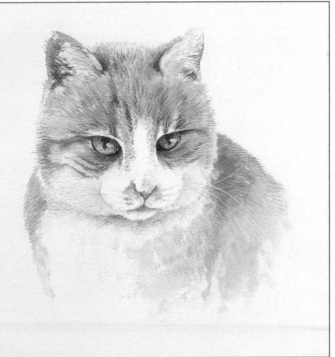

STILL LIFE

1 Saucepans: monotone drawing

A monotone drawing is one that is devoid of colour, giving the appearance of being 'black and white'. In fact a monotone picture contains many tones of a hue – light, mid and dark. The tonal value of a picture, if done correctly, can produce a three-dimensional effect on a two-dimensional surface. This demonstration will show you how to achieve this using the background colour of your support together with a limited number of similar colours.

MATERIALS

Pencils: Derwent watercolour pencils (used dry): Ivory Black 67, Chinese White 72, French Grey 70, Gunmetal 69, Blue Grey 68, Indigo 36

Soft white pencil (optional)

Paper: Tracing paper, Light grey pastel paper

Additional equipment: Pencil sharpener, Fine sandpaper (glass-paper) or emery board, Putty or plastic eraser

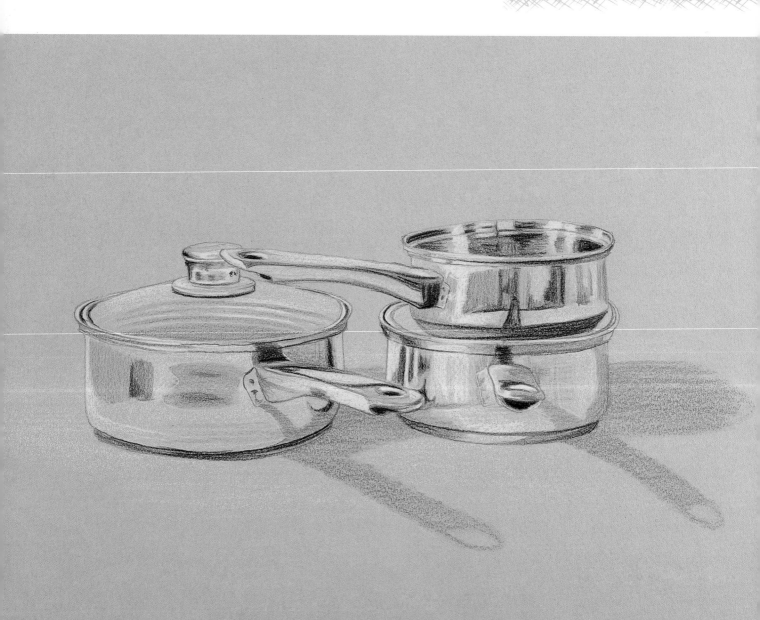

The support

This is an exercise using black, grey and white so the support must allow for the use of the white pencil for highlights. With this in mind a light grey pastel paper has been chosen, and the smooth side will be used because it is easier to work with.

Reference photograph

Setting up your own still life will eliminate some of the compositional problems that arise when using photographs as a source of reference. In this photograph the handles have been positioned so that they point in different directions. This gives a feeling of spontaneity, rather than having them point in the same direction, which can seem a little regimented.

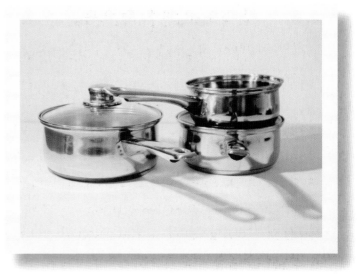

1 Start by tracing down the outline with the black pencil (Ivory Black 67). Remember not to press too hard because this could incise a groove into the paper, and if the pencil line is too strong it will be difficult to erase should you make a mistake. When you are happy with the outline start to block in the light shapes with white (Chinese White 72), pressing as hard as you can for the brightest highlights. Look at the shapes on the saucepans and draw in the shapes that you see, no matter how odd they may look. Also, using horizontal strokes, put in some of the white shading underneath the saucepans to give the impression of a flat surface; otherwise they will look like they are floating in space.

■ TIP: converting to black and white

If you are having trouble converting a colour photograph to black and white in your mind, try to find a way of having it printed in black and white. If you have access to a computer, scan the photograph in and, using photo-editing software, convert the picture to greyscale and print a copy off. Alternatively, take the photograph to a local printer/copier shop and have them do a black-and-white copy for you.

2 Using a mid-tone grey (French Grey 70), start to shade in some of the areas that are slightly darker than the whites in the photograph. The grey used here is slightly darker than the grey of the paper. When you have done this, start to indicate some of the darker areas with a darker grey (Gunmetal 69) and try varying the pressure on the pencil to give lighter and darker variations of the same grey.

3 Using the darker grey (Gunmetal 69), shade in the shadows of the pans on the flat surface they are sitting on. Use a horizontal shading technique that will help give the impression of a flat surface. Try not to make the edge too sharp because you want to achieve a sense of softness to the shadows.

■ TIP: flat shading
When trying to achieve a flat, shaded area, it is best not to use a sharp pencil. Try rubbing the pencil from side to side on some sandpaper (glass-paper) or emery board before starting on your drawing.

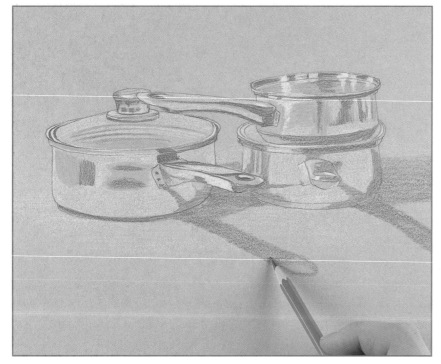

4 Now start to strengthen some of the darker shapes and shadows with a darker grey (Blue Grey 68). Some of the harder lines need to be redefined so use the same grey pencil to put these back in. Putting in the darker parts of the drawing will make the other areas seem lighter, so the next step is to compensate for this.

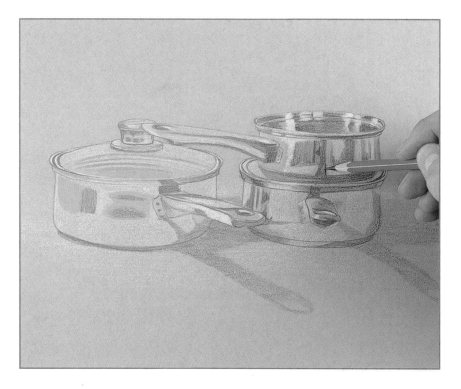

5 Using the darker of the two mid-tone greys (Gunmetal 69), strengthen some of the grey areas on the pans and also the shadows thrown by the pans, which now look lighter in contrast to the darker grey used in Step 4. Remember to use horizontal shading on the shadows of the handles.

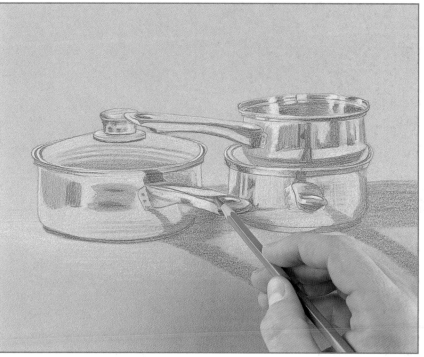

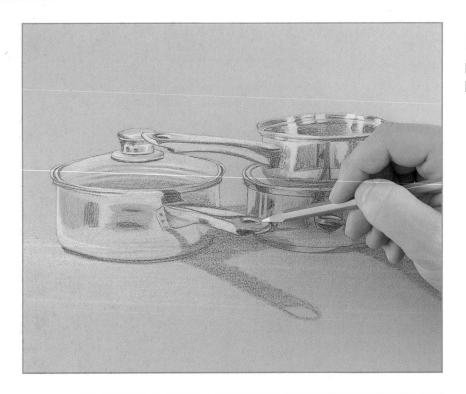

6 Using the white, strengthen the highlights, especially around the rims and on top of the handles. You can use a softer white for stronger highlights, although this is optional.

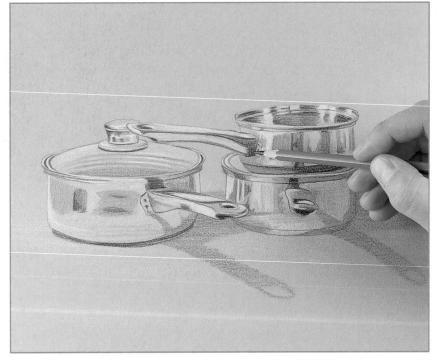

7 Some of the darker parts of the drawing now need to be stronger. Use a dark blue (Indigo 36) to strengthen these dark areas. This will give the drawing more impact and contrast.

8 To give the drawing a final edge and help with the contrast between light and dark, use the black pencil to strengthen some of the very dark areas. Use a sharp pencil to work up to the hard edges, pressing down as hard as possible without breaking the point.

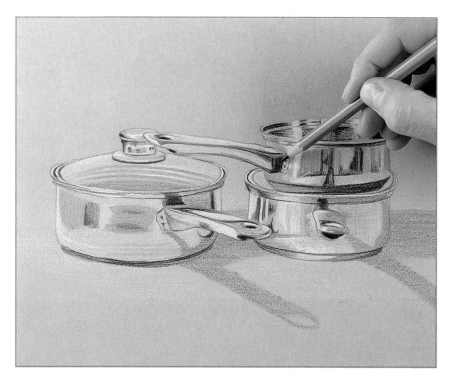

Technique check

This has been an exercise in tonal work where the actual use of colour is limited. You have been shown how to use a coloured background that gives a basic middle tone to work on and, therefore, cuts out a lot of work that would have had to be done on a white support. Hopefully this demonstration will have taught you how to think in terms of light and dark first, rather than thinking too much about the colour.

A step further: drawing glass

How do you draw glass when there is hardly any colour visible? Take a close look at this photograph. The facets in the cut glass pick up the light, the background colour and the liquid colour on the inside of the glass. You will need to study the effects and allow for each one of these facets, especially where the light catches the edges on a dark background, such as the highlights on the sherry glasses. On the decanter itself, especially the top half, the facets pick up the background colour only slightly darker; about the same colour as the shadow. When

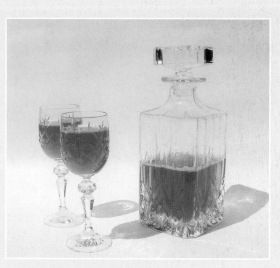

tracing the basic outline you will need to put in all these facets, otherwise you will not be able to achieve that cut-glass look. Try doing a small section or one glass to begin with. Remember, it is up to you how much you do.

STILL LIFE

2 Fabric: freehand technique

The freehand technique uses no drawing aids, including tracing down. This is a good exercise in learning how to look carefully at a subject and how to draw what you are looking at rather than relying on a tracing to do the work for you. It is a technique that, with practise, can add excitement and spontaneity to many subjects.

MATERIALS

Pencils: Derwent watercolour pencils (used dry): Chinese White 72, Primrose Yellow 4, French Grey 70, Gunmetal 69, Blue Grey 68, Indigo 36

Soft white pencil (optional)

Paper: Light brown or cream pastel paper

Additional equipment: Pencil sharpener, Fine sandpaper (glass-paper) or emery board, Plastic eraser

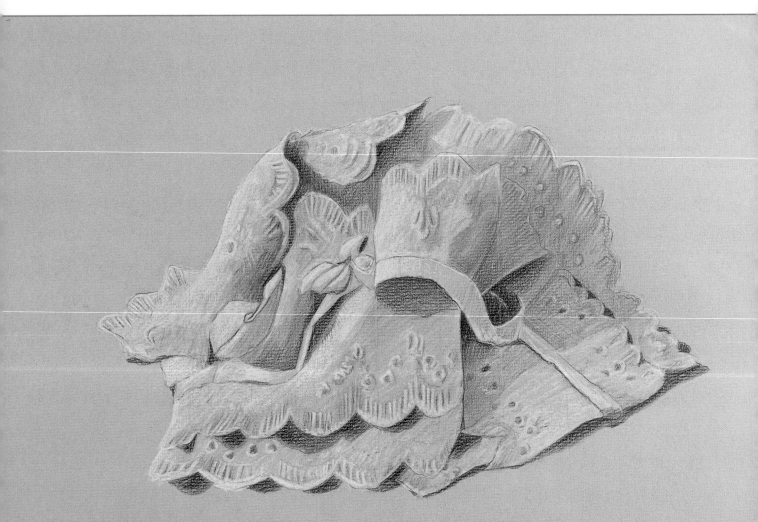

The support

Choosing the right coloured paper for this exercise was relatively easy. Using a colour that matches the overall middle colour of the photograph will cut out a lot of the work, so that all you need to concentrate on is the light and dark areas. The colour of the paper should provide you with a readily available middle colour to work on.

Reference photograph

Because this is an exercise in sketching, rather than creating a highly finished drawing, you do not have to worry too much about all the lace detail. You may decide to make the darker parts, especially the shadows, darker still to give more contrast.

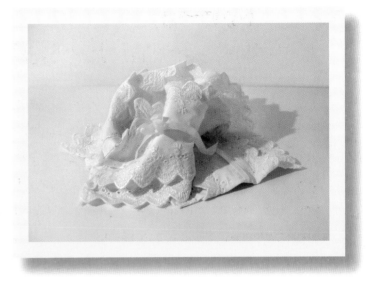

1 Using the white pencil (Chinese White 72) start to lightly sketch the outline of the crumpled fabric. Try looking at parts of the material rather than the whole to make the process easier. Do not worry too much about how accurate your drawing is in comparison to the photograph. Accuracy in this particular subject is not important. Once you are happy with the basic drawing, start to shade in the white areas, varying the pressure of the pencil to create the roundness of the folds. Next, using a light yellow (Primrose Yellow 4), shade in the silk ribbon. Start to shade in the shadows with a medium grey (French Grey 70) and use it to indicate the darker areas of the lace pattern.

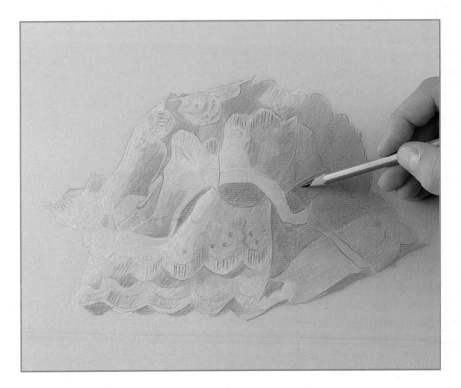

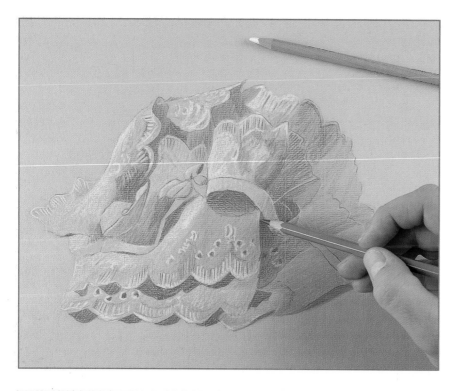

2 This step concentrates on building up the shadow areas and highlights. Start by shading in some of the darker areas with a dark grey (Gunmetal 69), pressing down fairly hard with the pencil. You can also use this pencil to redefine some of the lace pattern and hard edges around the ribbon. Next, by releasing some of the pressure on the pencil, shade in some of the lighter areas. Finally, using the white, pick out some of the stronger highlights especially around the edges of the lace and the ribbon. If you have a softer white pencil than the Chinese White 72, use this to strengthen the highlights.

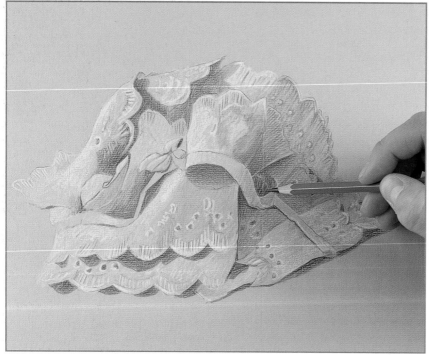

3 Choose a darker, bluer grey (Blue Grey 68) and start to shade in the darker shadows on the material. Look for areas of contrast such as the edge of the ribbon and try to maintain a sharp edge where the light and dark areas meet. Using a bluer grey will give a cooler, darker shadow, which is better on the eye than a warmer grey.

■ TIP: textured support

As you apply more pressure and, therefore, more colour, you will notice the texture of the pastel paper start to come through. Do not fight the paper by trying to fill in the texture. One of the reasons for picking a textured support is to accentuate the texture of the material itself.

4 Having completed the light and dark parts of the drawing, use a mid-tone grey (French Grey 70) to burnish over the top of the white and grey to bring the picture together. Do this by rubbing the grey lightly over the whole drawing including the white, except for the yellow ribbon. (See Burnishing page 18.) This will have the effect of unifying the different tones and colours of the drawing.

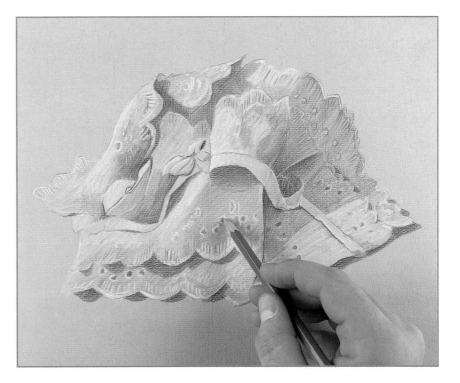

5 Using the white, go back over the highlighted areas of the white lace applying as much pressure as possible with the pencil. Pay particular attention to the sharp edges, especially where they meet the dark shadow areas.

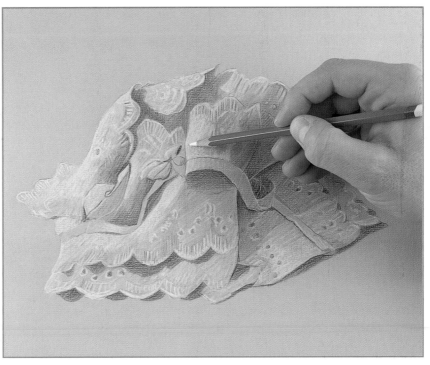

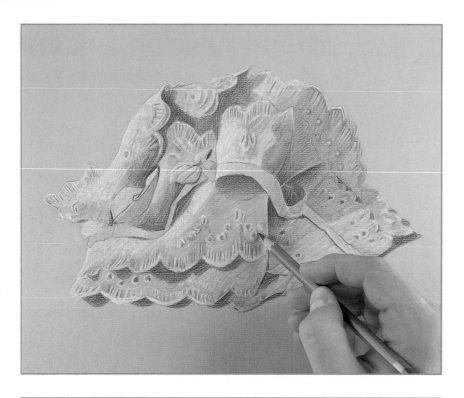

6 Some of the lace detail is looking a little soft, so, using a dark grey (Gunmetal 69) sharpen the grey areas next to the lace highlights. Do not apply too much pressure as this will look too heavy.

7 Using a dark blue (Indigo 36), strengthen some of the darker shadows to create more contrast. This will also give you an idea of how much highlight to finish off with.

8 Finally, use the white to put in some of the stronger highlights, especially around the lace detail and on the parts of the yellow ribbon that are catching the light.

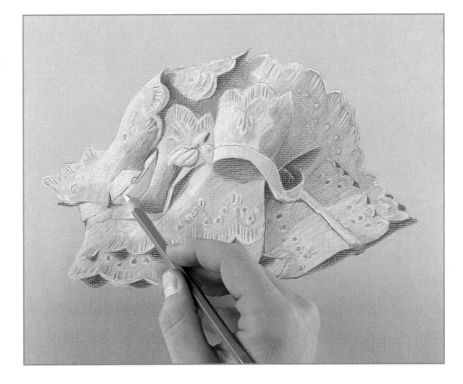

Technique check

Doing a freehand exercise so early in the book may have been a challenge, but the choice of subject matter will have helped because it is not essential to get the contour and the hard lines in exactly the right place. More importantly, you will have learned how to look at shadows and highlights to generate a three-dimensional representation on a two-dimensional surface.

A step further: darker background

This is a good subject to practise working on a darker background. Choose a support such as mount (museum) board that can handle a lot of layering, since you will need to lay down twice as many layers for this subject as you did in the main demonstration. You may find that the watercolour pencils you are using are not quite soft enough to lay down a bright colour on this dark background. Try experimenting with some of the other makes of pencil, especially the non-water-soluble pencils, which may be softer.

This subject has a lot more creases and folds in it, so try using the Tracing down method (see page 22) for the initial outline and then go back over your outline with a sharper white pencil to give a sharp line to work to.

STILL LIFE

3 Fruit: fresh and bright colours

Maintaining fresh and bright colours with careful colour mixing is very important, no matter what art medium you use. However, unlike mixing paint, in order to achieve a certain colour with dry pencils you need to use a technique called 'optical mixing'. Even if you have a full set of pencils, it is sometimes difficult to choose the correct colour, so by layering one colour on top of another you can mix the colours together on the paper. This demonstration will show you how to blend and layer different colours together.

MATERIALS

Pencils: Derwent watercolour pencils (used dry): Deep Chrome 9, Deep Cadmium 6, Gold 3, Raw Umber 56, Burnt Umber 54, Deep Vermillion 14, Olive Green 51, Prussian Blue 35, Geranium Lake 15, Naples Yellow 7, Venetian Red 63, Indigo 36

Paper: Tracing paper, White, smooth, 300gsm (140lb) watercolour paper

Additional equipment: Pencil sharpener, Fine sandpaper (glass-paper) or emery board, Plastic eraser

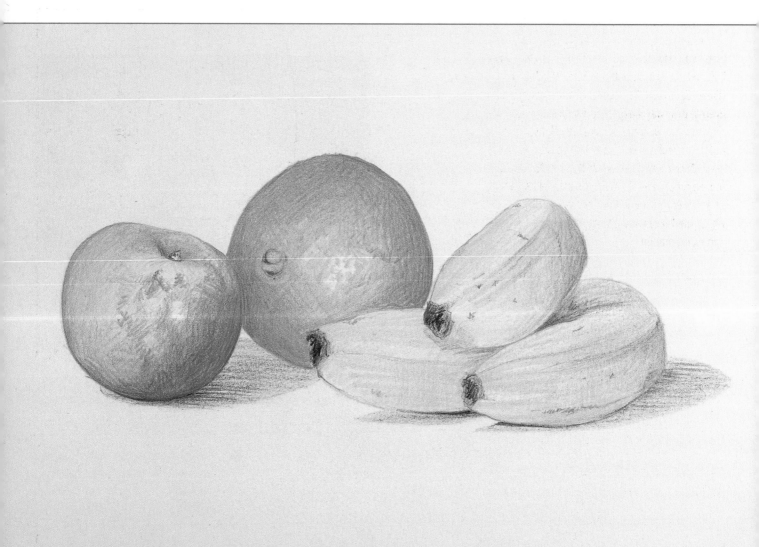

The support

This demonstration uses light layering and, in some places, burnishing, so smooth watercolour paper is a good surface to work on. The thicker the better. It has a velvety feel to it and will take a certain amount of erasing and burnishing. Also, being watercolour paper, you have the option of using the pencils in conjunction with water should you need to employ more delicate shading.

Reference photograph

Hardly any changes are needed here. The strong light source has given the apple and orange some highlights, which you will have to work around, and the shadows will need to be darkened.

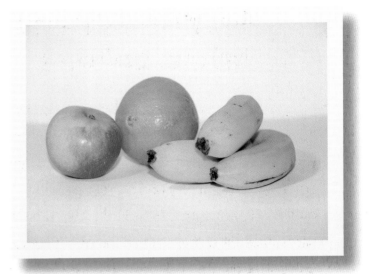

1 Trace down the outline in orange (Deep Chrome 9), which will not be as noticeable when you have finished the drawing as a darker colour such as blue or black. Starting with yellow (Deep Cadmium 6), begin to shade in the fruit. Even at this early stage try to establish the light and dark areas by varying the pressure of the pencil. Try not to make the pencil lines too hard. If the lines are showing, blunt the pencil by rubbing from side to side on a piece of fine sandpaper (glass-paper) or an emery board. Remember to leave the highlighted areas as white paper, especially on the apple and orange.

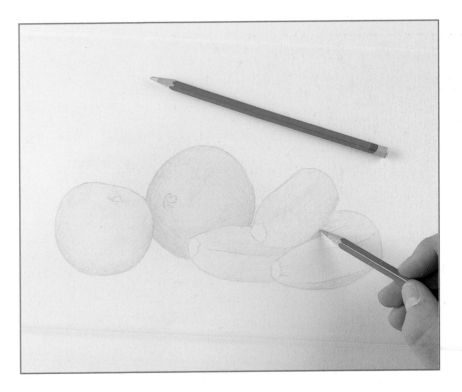

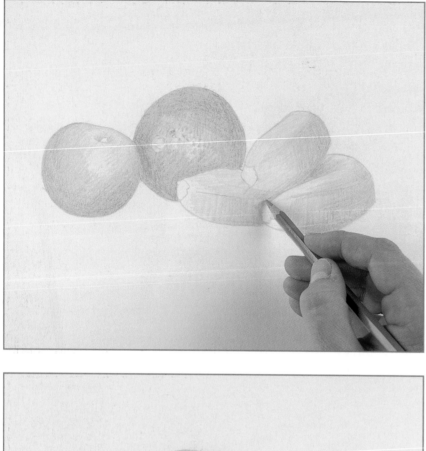

2 Using the same yellow and orange (Deep Cadmium 6, Deep Chrome 9), start to build up the colours of the apple and orange by applying more pressure with the pencil. Use the yellow to begin with on both the apple and the orange and try to shade using curving pencil lines that follow the shape of the fruit. If you find this awkward use horizontal and vertical lines overlapping or cross-hatching each other to shade in. Remember to work around the highlight areas. On the orange the texture of the skin has given the highlights a 'spotty' appearance. So, when working around this area, start to flick in some of these spots with the orange pencil. For the bananas use a cooler yellow such as a lemon colour (Gold 3) and shade in the side of the bananas facing away from the light source. Try to shade vertically since this will help with the structure of the bananas.

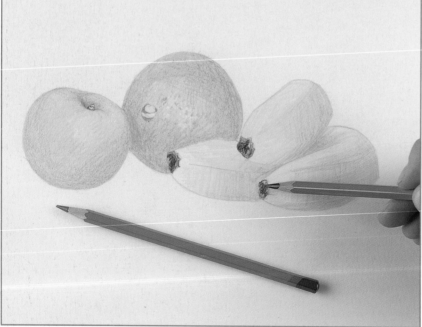

3 Add in some of the dark features of the fruit to give an idea of how light to make the rest of the picture. Starting with the apple and orange, use a light brown (Raw Umber 56) to put in the stalk of the apple and the navel of the orange. You can also put in the shaded area around the apple stalk with the same pencil. Next, put in the ends of the bananas with a darker brown (Burnt Umber 54).

■ TIP: wax resist

Oranges have a unique texture to their skin that is difficult to achieve using coloured pencils dry. One way to do it is to use the pigment wet (see Dissolving colour with water page 21) and in combination with a technique called 'wax resist'. Before applying the wet pigment, rub the textured area of the orange with a household wax candle. Paint the wet pigment onto the orange and over the area you have applied the wax to. The watercolour pigment will not adhere to the paper where the wax is because the wax is greasy. This should give you a good impression of the textured skin of an orange. For best results use a not surface watercolour paper.

4 Start to warm up the apple and orange by applying a warm red (Deep Vermillion 14) to the right side of the apple and around the edge of the orange. Do not try to achieve the correct strength of red with the first layer but build it up with successive layers.

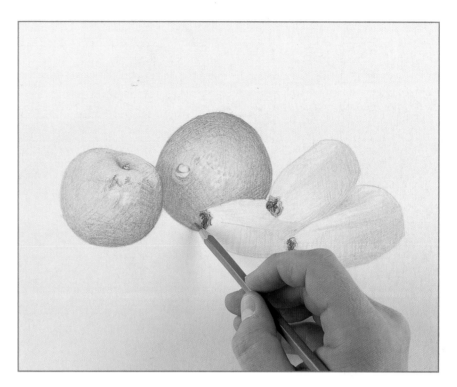

5 Using the deep yellow (Deep Cadmium 6), strengthen the whole of the bananas with an even shade of colour, then, using a deep, warm green (Olive Green 51) start to shade in the darker, shadow sides of the bananas. You can also use this green to shade in the area around the stalk of the apple. If you do not have a suitable green, try using a blue and shade lightly over the yellow colour. The combination of the yellow and blue should create a green.

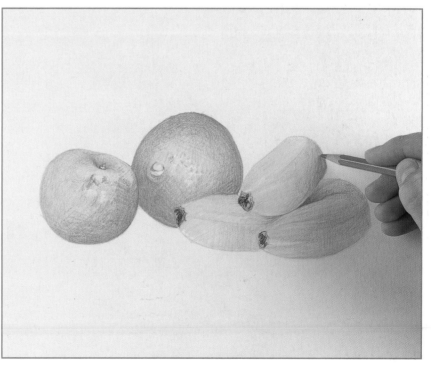

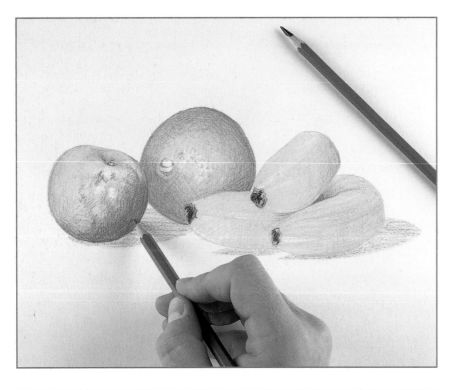

6 At this stage the fruit look like they are floating in space, so the shadows need to be put in. Using a dark blue (Prussian Blue 35), shade in horizontally underneath the fruit. Try to maintain a sharp edge when shading. You can also sharpen the edge of the shadow with an eraser. Next, start to build up the red of the apple using a stronger red (Geranium Lake 15) than in Step 4, still working around the highlights.

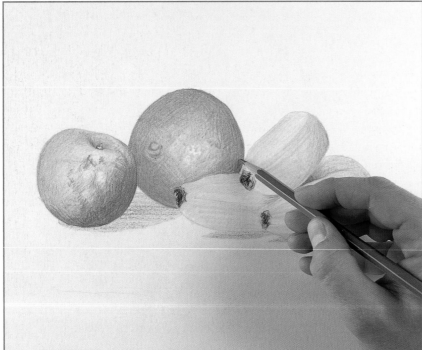

7 The picture needs to be unified using a lighter colour burnished over the top. Choose a warm yellow (Naples Yellow 7) and use this to create a glow to both the apple and orange by shading over the top of each fruit. Some of the yellow can also be put on the bananas but do not shade in too much because the bananas have more of a lemon yellow colour to them. Remember to work around the highlights. Using a warm red brown (Venetian Red 63) shade in some darker colour to the edges of the orange and apple.

8 Using a dark blue (Indigo 36) lightly shade over the dark side of the bananas. The combination of the yellow and light shading of the blue should give you a green shadow. Finally, use the light brown (Raw Umber 56) to put in the brown marks on the bananas.

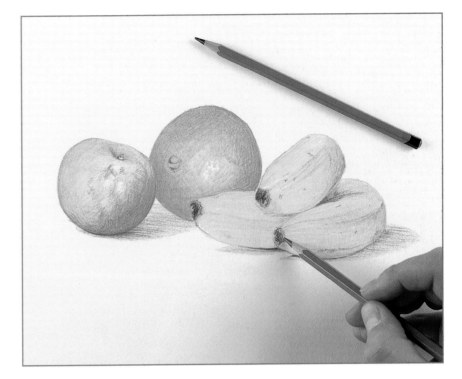

Technique check

The object of this demonstration was to show you how to apply one colour over the top of another and how they influence each other. During the demonstration you used reds on top of yellows to create warmer reds and oranges, and blues on top of yellows to create greens. Also you were shown how to shade in the same direction as the contours of the fruit to achieve the roundness of the shapes.

A step further: composing a still life

When composing a still life there are a few things to remember. First of all, try to place an object in or near the foreground. This will help lead the eye into the picture, but try not to use anything that is too dominant. In this photograph an apple has been placed in the foreground with the stalk pointing forwards, and another apple in the bowl with the stalk pointing in the opposite direction. The eye goes to the nearest stalk first, then on to the stalk of the next apple. Having the main body of fruit sitting in the bowl gives a sense of comfort and security to the composition and also intimates that the apple in the foreground is trying to escape. One more thing that is worth pointing out is that the apple in the foreground slightly overlaps the fruit bowl. This is intentional. A space between the apple and the fruit bowl would give the impression of two separate pictures; one of the apple and one of the fruit bowl.

STILL LIFE

4

Flowers:
working wet and dry

This demonstration uses the versatility of the watercolour pencil with its ability to be used as a watercolour medium as well as a dry pencil. The initial washes will enable you to apply light layers of colour and help maintain the vibrancy of the flower petals.

MATERIALS

Pencils
Derwent watercolour pencils
 (used wet and dry):
Deep Cadmium 6
May Green 48
Olive Green 51
Cedar Green 50
Naples Yellow 7
Deep Chrome 9
Blue Grey 68

Paper
Tracing paper
White, not surface, 300gsm
 (140lb) watercolour paper

Additional equipment
Pencil sharpener
Fine sandpaper (glass-paper) or
 emery board
Putty eraser
Size 4 or 6 round watercolour
 brush
Jam jar
Tissues

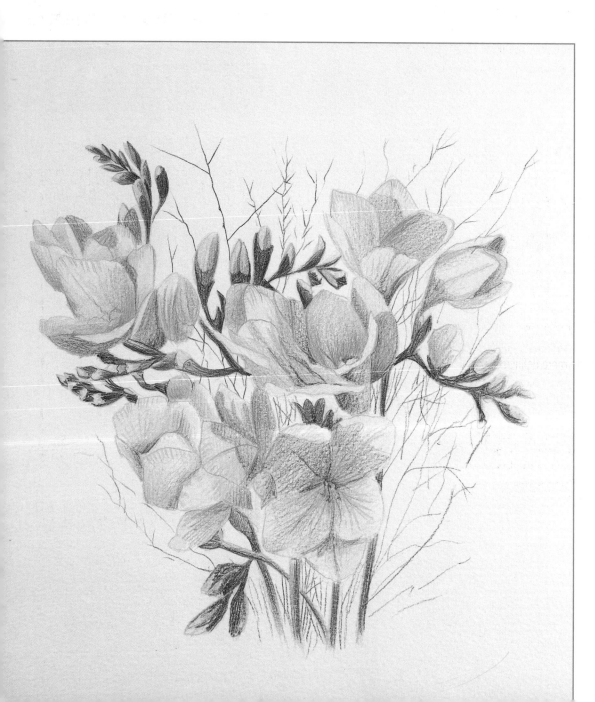

The support

For this exercise choose a not surface watercolour paper. The word 'not' refers to the amount of surface texture on the paper. If you are buying a pad, the type of surface should be printed on the front cover. If not, then any good art materials supplier should be able to choose the right one for you. Also, choose a paper weight or thickness of 300gsm (140lb). This should be indicated on the cover of the pad.

Reference photograph

Even though this is a sharp picture, there are parts of the flower petals that are difficult to make out. Try to establish the outlines of the petals before applying the washes. Pencil lines can be rubbed out but washes are more difficult to correct when dry. There is also a large amount of background greenery so, to make life easier, concentrate on the yellow flowers and green buds and simply indicate the green twigs with a few lines. Remember, you do not have to depict everything you see in the photograph.

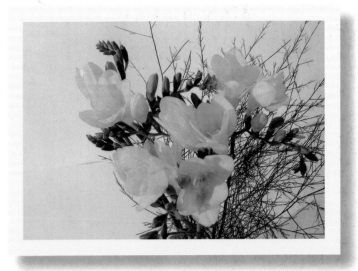

1 Start by tracing down the outline of the flower petals with the same yellow (Deep Cadmium 6) that you will later use to colour in with. Then change to a light green (May Green 48) to draw in the green buds and stalks. When you are happy with the outlines, start to shade in the petals with the yellow, but do not press too hard. Apply a very light shade over each petal. Do the same with the green buds and stalks using the green pencil. You may find in places that you lose some of the flower and petal outlines. You can create more definition later when you apply the water.

■ TIP: pigment strength

Only apply a light area of colour at this stage because, when wet, the pigment can appear very strong, depending on the colour being used. If you are not sure how light to go, do a test on scrap watercolour paper, then wet it with the brush to see how strong it appears.

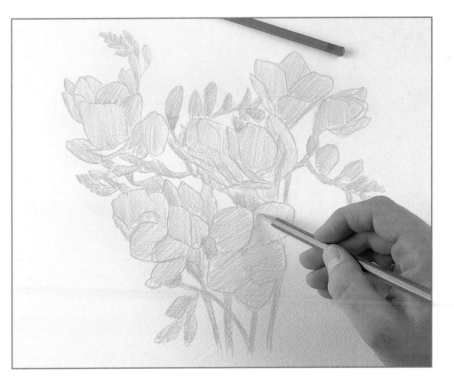

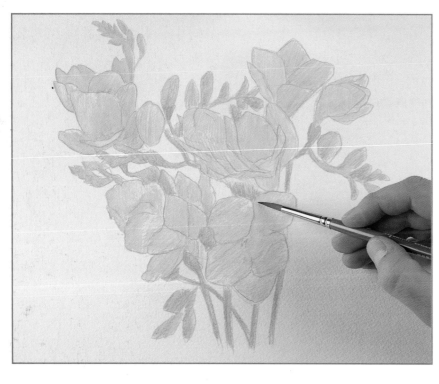

2 Wet a watercolour brush and start to paint over the yellow pencil colour you have shaded in. Paint each petal to start to define the petal edges. Where the highlight on the petal is lighter, try pushing the paint from the lighter areas to the darker part of the petal. While the pigment is wet, some of the highlights can be picked out by blotting with a tissue. When you have completed the yellow petals, clean the brush thoroughly and, using clean water, brush over the green buds and stalks using the same technique.

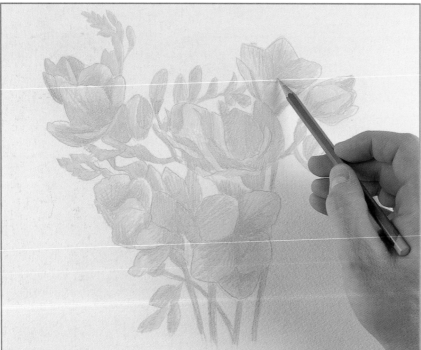

3 Using the same yellow as in Step 1 (Deep Cadmium 6), start to shade in the darker parts of each flower petal. Shade from the centre of the petal outwards, releasing the pressure of the pencil as you get to the edge to create a graduated shade of colour. It is during this stage that you start to define the individual petal edges.

4 Use the same technique as in Step 3 on the green buds and stalks using the light green (May Green 48). Vary the pressure from top to bottom of each bud to achieve the graduation from light to dark.

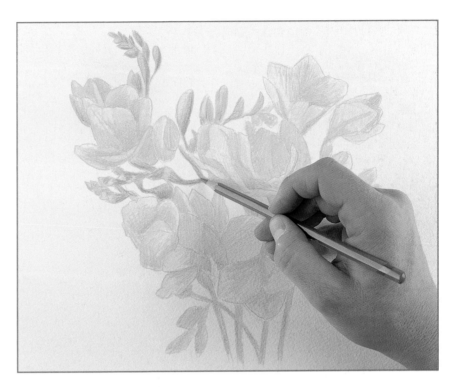

5 Go back to the flower petals and start to deepen the shadow areas with a warm green (Olive Green 51). Try to establish the hard lines between each petal. Some of these may look a little odd at this stage. You will be using a warmer, orange yellow later in these areas.

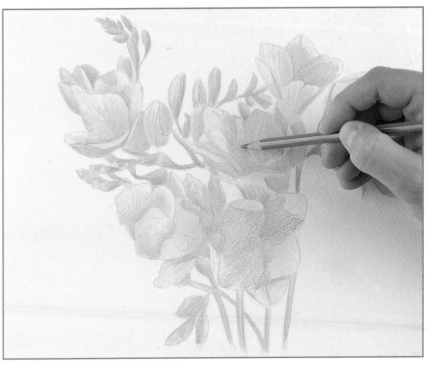

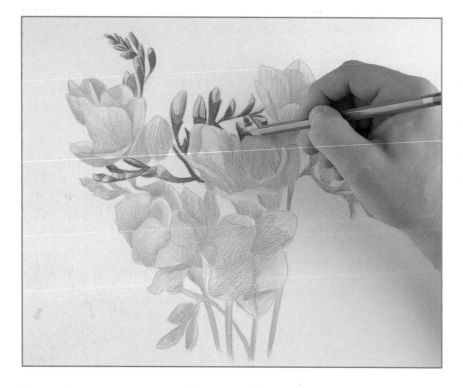

6 Use a dark green (Cedar Green 50) to add in the darker parts of the buds and stalks. You will need to press hard to put down as much pigment as possible. You will not be putting any more pigment onto the buds and stalks once you have completed this stage, so try to maintain sharp edges and highlights. Work one bud at a time and remember not to fill each bud in with the dark green, otherwise they will look too flat.

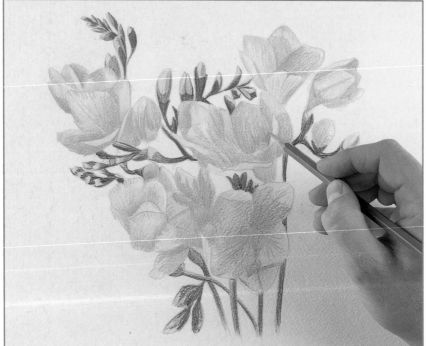

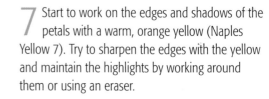

7 Start to work on the edges and shadows of the petals with a warm, orange yellow (Naples Yellow 7). Try to sharpen the edges with the yellow and maintain the highlights by working around them or using an eraser.

8 You still might have a problem with lack of definition in the flowers, so choose a strong orange (Deep Chrome 9) and repeat the process described in the previous step. Next, using a blue or blue grey (Blue Grey 68), darken the shadows on the petals by lightly shading over the warm green (Olive Green 51) put down in Step 5. Using the green of the stalks and buds (Cedar Green 50) put in the thin twigs. Keep the pencil sharp and work out from the flowers.

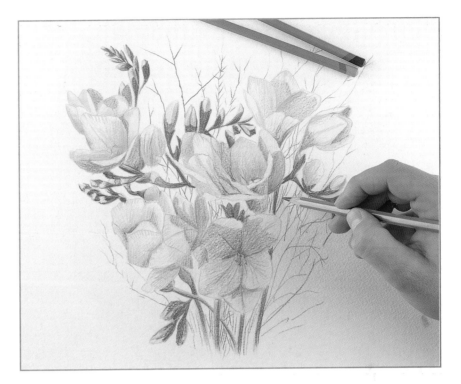

Technique check

Using wet and dry pigment in the same drawing will feel quite strange to begin with, but this demonstration has shown how versatile the water-soluble pencil can be. By painting with wet pigment to begin with a basic colour was established that should still be visible in places and will therefore give the overall picture a unifying feel.

A step further: dry pencil drawing

The main demonstration used the pencils wet and dry, which enabled you to lay down delicate washes with the brush. This particular photograph is of a light pink rose on a dark background. You could use the wet-and-dry technique to paint this rose, but you would struggle to see your work on a white support. It is not advisable to use the wet technique on a dark background because, when wet, the pigment is transparent and so it would be difficult to achieve a bright pink using this method. In this case the solution would be to build up the pink

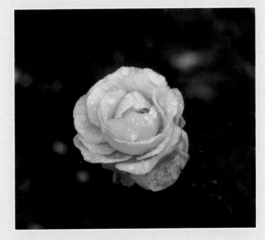

using dry layers. Also in this photograph you can see a lot of water droplets. These can work well in flower painting because they add a sense of freshness to the picture. However, there are too many droplets in this picture so just pick out a few of them.

LANDSCAPE

1 Beach scene:
texture and detail

This particular subject features a variety of different textures and surfaces from the leafy tree line to the pebble beach, so the demonstration will show you how and where to apply certain textures and details using a variety of pencil lines and strokes. These techniques are a useful aid to sketching landscapes with coloured pencils.

MATERIALS

Pencils: Derwent watercolour pencils (used dry): Cedar Green 50, Light Blue 33, Burnt Ochre 57, May Green 48, Venetian Red 63, Van Dyke Brown 55, Burnt Umber 54, Ivory Black 67, Raw Sienna 58

Paper: Tracing paper and white cartridge (drawing) paper

Additional equipment: Pencil sharpener, Fine sandpaper (glass-paper) or emery board, Plastic or putty eraser

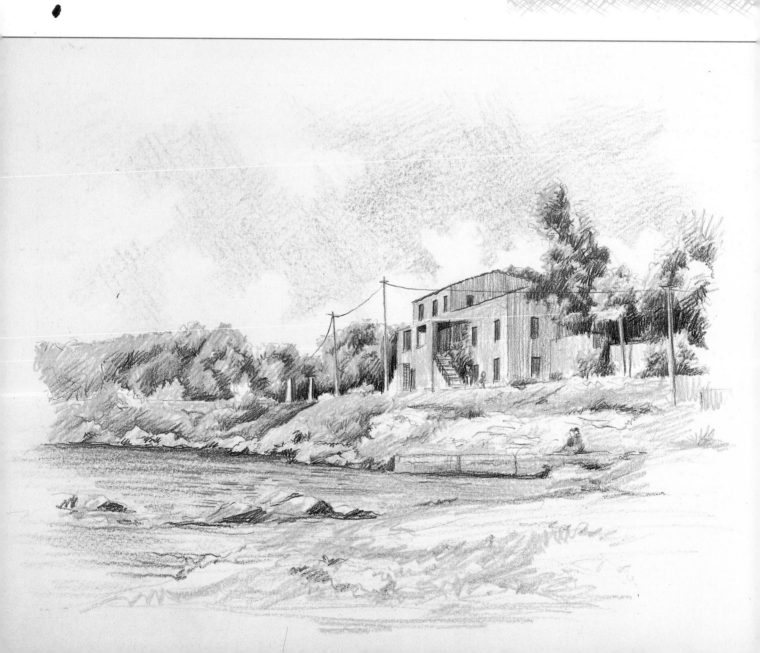

The support

Cartridge (drawing) paper is used for this demonstration. It has an off-white, relatively smooth surface and is ideal for sketching and colouring, and the surface allows you to apply almost any kind of coloured-pencil technique. Cartridge (drawing) paper is thinner than some of the other surfaces used so far, so it is a good idea to keep the paper in the pad or tape it to a board with a few sheets of newspaper or scrap paper layered underneath.

Reference photograph

Landscape photographs tend to include too much detail in places, so you will need to simplify some areas of the picture. If you look closely you can see a few figures. Leave out the sunbather on the right but leave in the others to help give a sense of scale.

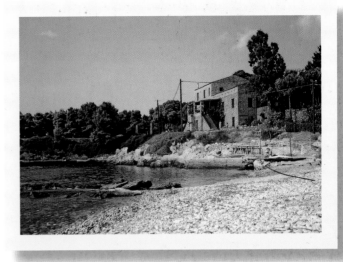

1 Trace down the outline using a dark green (Cedar Green 50). Using a light blue (Light Blue 33), start to shade in the sky leaving white areas of paper for the clouds. Try to use the pencil in a more horizontal position than vertical because this will give a more even shade with less pencil lines showing. Turn the paper through 90 degrees and repeat the process. This is called cross-hatching and will help eliminate more of the pencil lines. Using the same light blue, but this time holding the pencil in the normal way, establish some harder edges to some of the clouds. Put some of the blue colour into the sea water as well. Now go back over the traced outline to sharpen some areas, especially the building. Use a light brown (Burnt Ochre 57) for the building, rocks and figures and dark green for the trees and bushes.

■ TIP: drawing with a plastic eraser

Another way to create white clouds on white paper is to use a plastic eraser to rub out white areas from the blue sky. If the eraser is dirty, rub the colour off on a spare piece of paper. If you need a sharper edge, carefully cut a piece off with a knife.

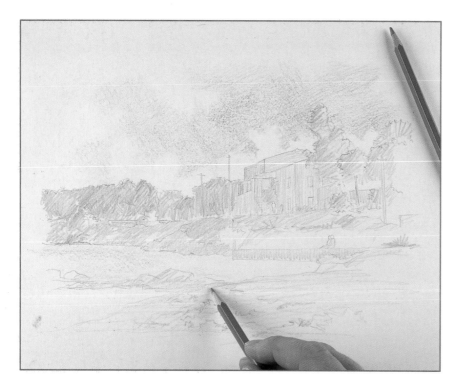

2 Starting with a light green (May Green 48), shade in the trees and bushes using a variety of different pencil lines to create texture. Do the same to the rocks and buildings using the light brown (Burnt Ochre 57), and use more defined, random pencil lines in the foreground to create texture on the beach. On the building try to shade in vertically to help with the structure.

■ TIP: practising foliage
Practise the trees and bushes on a separate piece of paper. Use a sharp green pencil to produce a range of circles, scribbles and marks of varying strength. Try to achieve a broken, rough edge to the trees rather than a solid outline.

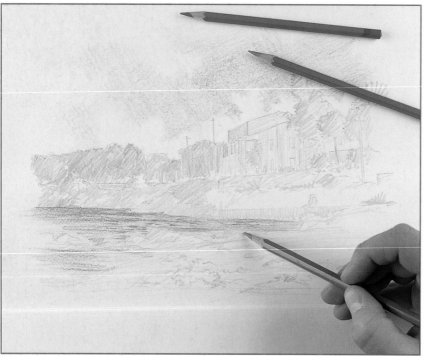

3 Using the same green and brown (May Green 48, Burnt Ochre 57) and also the blue used for the sky (Light Blue 33), start to shade in the water using horizontal pencil strokes. The water should appear darker at the shoreline in the distance and lighter in the foreground where it meets the beach, because of a combination of shallow water and colour reflection at the shoreline. Use the blue pencil to flick in a few short, horizontal lines to indicate the ripples in the water.

4 Using the dark green (Cedar Green 50), start to fill in the dark shadow areas of the trees and bushes, remembering to leave spaces for the telephone poles and the light on the treetops. You may find it easier to start by using a light shading technique that you then go back over, as can be seen on the trees on the right of the building.

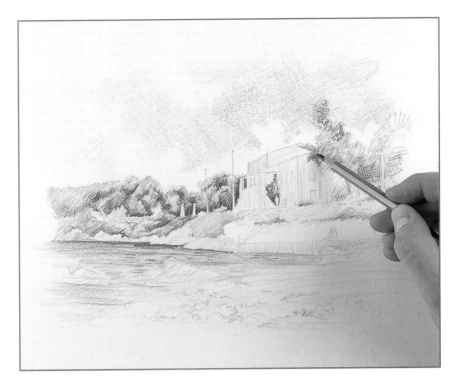

5 Use a red brown (Venetian Red 63) to put in the windows and a darker, cooler brown (Van Dyke Brown 55) to shade in the sides of the building that are in shadow. Redefine the steps and the telephone poles with the same dark brown.

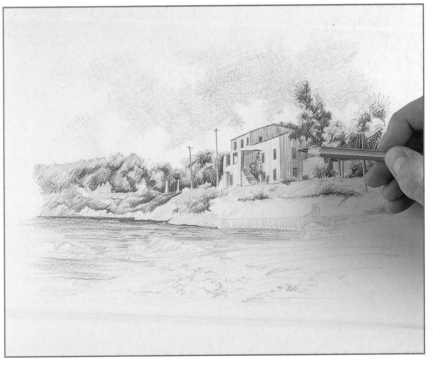

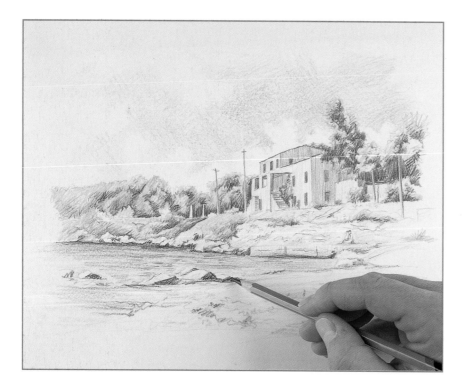

6 Now that some areas of the picture have been darkened, others will look too light. Using a dark brown (Burnt Umber 54), put in the rock detail in the distance and middle ground where it meets the water. Try to make the rock detail in the distance slightly lighter than the middle and foreground to achieve a sense of perspective.

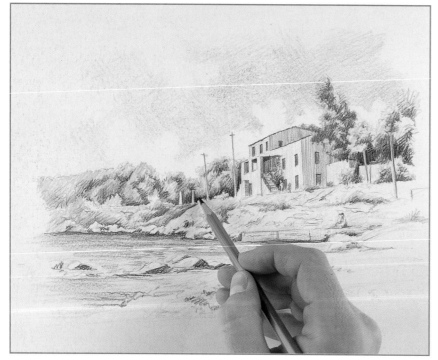

7 Using a black pencil (Ivory Black 67), strengthen some of the tree shadows, especially where they meet the light coloured wall on the right. Also, with the same black pencil, put in some black edging to the front of the building and the windows.

8 Some of the middle and foreground needs to be warmed up so choose a raw sienna (Raw Sienna 58) and lightly shade over the rocks and beach area. Next, use a sharp black pencil to put in the telephone cables. Finally, choose a few colours to fill in the figures.

Technique check

This scene has allowed you to practise the various sketching techniques used by landscape artists. Sketching is a way of gaining information on colour and tone (light and dark) and the coloured pencil is an ideal tool for this because of the variety of textures and pencil lines that can be achieved by using it.

A step further: using flat layers

This is a wonderful photograph of a sunset and is a good subject to use to practise flat and graduated shading techniques. Choosing a support to work on can be difficult. You will need a good, smooth surface, such as a smooth, white watercolour paper or a light grey mount (museum) board. Try doing some preliminary sketches on scrap paper or board before starting the final picture. When doing the flat shading try not to bend your wrist. Keep it locked in the same position and move your arm from the elbow and shoulder. This way you will, with a bit of practice, maintain a straight shading motion rather than a curved one. When shading a graduated layer remember to start heavy and begin to release the pressure on the pencil as you move towards the lighter end of the layer. You do not have to leave the space for the boat since this can be put in dark over the top of the sunset and water.

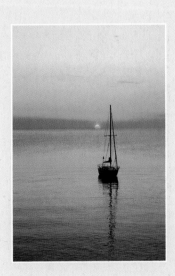

LANDSCAPE

2 Water:
using a limited palette

The photograph in this demonstration has very few colours in it and also has an overall blue-grey feel that can be replicated using a limited palette. This exercise illustrates how to achieve a unity throughout a picture by using pencils and a support of similar colours and also how a small area of a different colour can bring life into a picture.

MATERIALS

Pencils: Derwent watercolour pencils (used dry): Chinese White 72, Blue Grey 68, Sky Blue 34, Gunmetal 69, Geranium Lake 15, Ivory Black 67, Light Blue 33

Board: Light blue grey mount (museum) board

Additional equipment: Pencil sharpener, Fine sandpaper (glass-paper) or emery board, Plastic eraser, Tissues

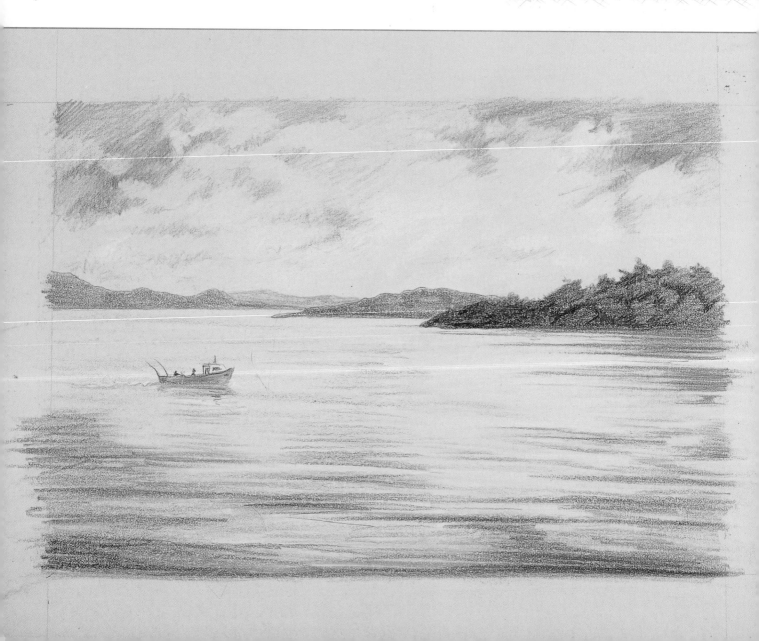

The support

The choice of colour to work on for this exercise will have a major influence on the finished picture. If you are buying a sheet of board from your local art supplier, take the photograph with you to help you choose the right colour. Mount (museum) board is used for this exercise because its smooth, rigid surface will enable you to achieve a smooth application of colour. If you cannot get hold of the board use a smooth paper.

Reference photograph

When drawing landscapes you want to achieve a sense of distance. Photographs, sometimes, do not do this. In this photograph the tree line in the middle ground is too dark so you will need to lighten it by as much as 30 per cent. Also, this photograph was taken at a slight angle that will need to be straightened. There are a few boats on the right-hand side but they are difficult to see. Move one of the fishing boats to the left to aid the composition and give a sense of scale, and leave out the rest of the boats.

1 There is no need to trace down the outline because the hills in the distance and middle ground, plus the little fishing boat on the left, can easily be drawn freehand. Start with the sky, using white (Chinese White 72) to shade in some of the lighter areas using a random shading technique. This will give a sense of movement to the sky. Move down to the water and, using horizontal pencil strokes, start to put in the lighter areas. Sketch in the outline of the boat. At this stage you can add in the hills and trees. Using a blue grey (Blue Grey 68), lightly shade in the tree line on the left but not the distant blue hills in the middle. Then, applying more pressure, shade in the middle and the right-hand tree lines with the same pencil. Now use a light blue (Sky Blue 34) to gently shade in the distant hills.

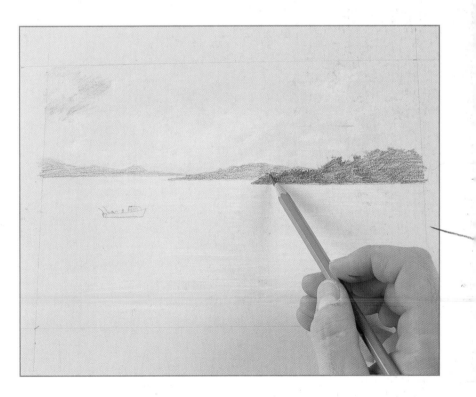

■ TIP: creating an edge

If you are not sure where to end the picture on the board, draw a box on the support to the same proportions as the photograph before you start working. This will give an edge to work up to.

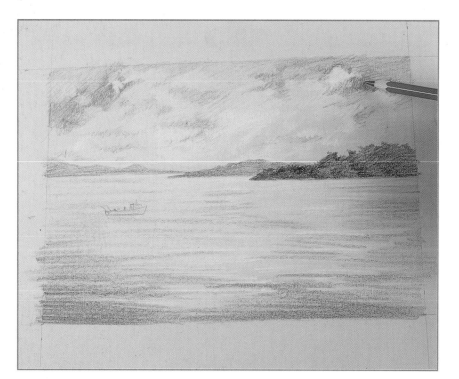

2 Start to darken some of the clouds with a dark grey (Gunmetal 69) varying the pressure of the pencil to achieve a greater range of greys. Because the sky at the horizon is further away you will need to lighten the grey clouds as you move down the sky. Use the same grey to put in some darker, horizontal lines in the water at the bottom of the picture. As in the sky, the horizontal pencil lines in the water will get lighter and thinner as they recede towards the horizon. Finally, use the white to rub over some of the grey clouds. This is called burnishing and will soften some of the harder pencil lines. (See Burnishing page 18.)

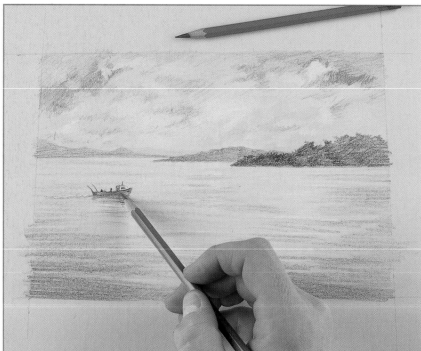

3 A picture using a limited palette can be livened up by adding a splash of colour. The best place to do this here is on the fishing boat. Colour in the boat with a warm red (Geranium Lake 15) and use the same red to put in the reflection under the boat. Give the boat a darker outline with the dark grey (Gunmetal 69) and, to give the boat a sense of movement, lightly sketch in the wake behind it, highlighting the wake with a little white.

■ TIP: a splash of colour
Choosing which type of colour to use as a splash of colour would depend on the overall colours used in the picture. Try using something that does not appear anywhere else in the picture.

4 Now that the sky and water are darker, the land and tree line will need to be darkened as well. Use the blue grey (Blue Grey 68) to shade in the three hills and tree lines, making sure the strong one is at the front and the lighter one at the back on the left. You may need to strengthen the front spit of land with some black (Ivory Black 67). Use a light blue (Light Blue 33) to shade over the distant blue hills and put some of this blue in the water as a reflection.

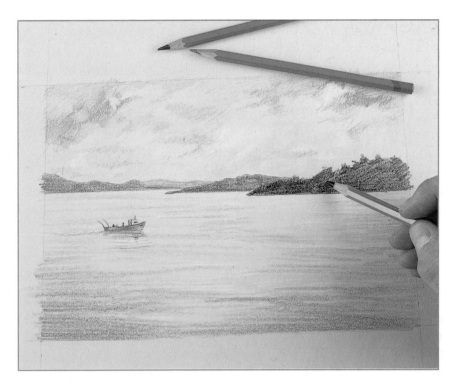

5 Use the blue grey (Blue Grey 68) to shade in the reflections on the water on the right side and the bottom of the picture, remembering to use horizontal lines to emphasize the flat water on the lake. Keep the pencil as sharp as possible.

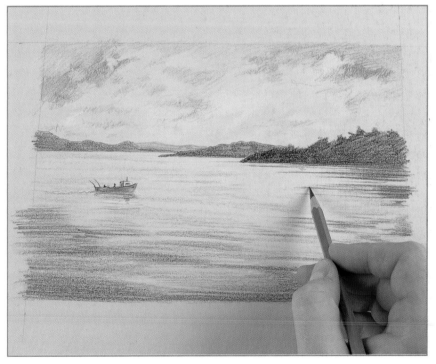

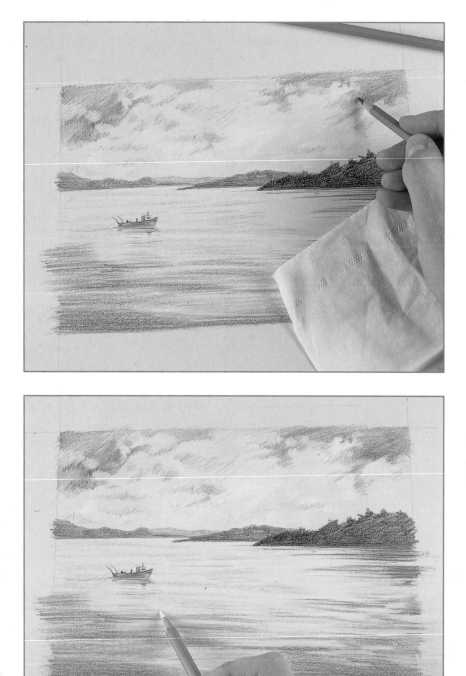

6 Using the same pencil (Blue Grey 68), darken the clouds at the top of the sky to balance the dark areas of water at the bottom of the picture. Vary the pressure of the pencil to achieve different strengths of grey. You may want to protect your previous work with a tissue under your hand.

7 Lightly burnish the clouds with white, then burnish over the dark water at the bottom of the picture using long horizontal strokes. Do not go over the boat since you do not want to smudge the red into the water.

8 To finish, use a sharp, black pencil to put in some shape to the trees on the right-hand side and add a bit more strength to the water in the foreground.

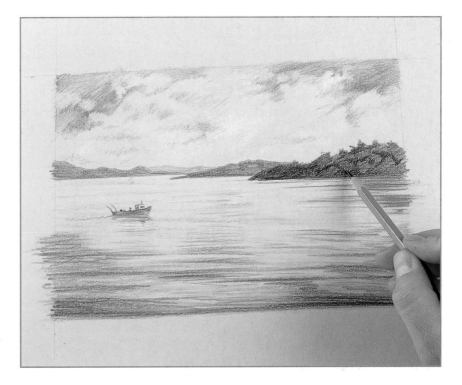

Technique check

Using a limited palette helps to give a drawing an overall feeling, and picking a particular coloured support to work on will also help. However, as you were shown in this demonstration, including a small area of a completely different colour can help bring some life into the picture. Try doing another picture but with a completely different set of coloured pencils and background.

A step further: moving water

There are two different techniques you can use to depict the moving water in this photograph. The easier way is to choose a mid-tone or dark background and use a white pencil to put in the moving water. You may need to use a softer pencil for the whiter areas of the picture. Another method, that is perhaps more difficult, is to use a white support and create the moving white water by drawing in all the darker areas around it, leaving the white of the support as the moving water. The latter method will enable you to achieve a

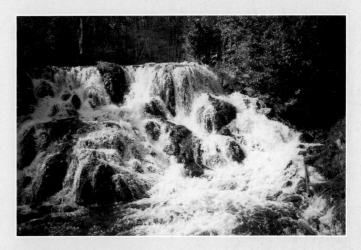

better tonal range – a greater range of greys – and therefore give you a better chance of achieving the feeling of the water cascading down the rocks. I'd recommend that you try out both methods and see which you prefer.

LANDSCAPE

Buildings:
solid structure

Drawing buildings and achieving a sense of solidity can be daunting. During this demonstration you will learn how to use vertical and horizontal shading to help establish the form and structure of the chosen subject.

MATERIALS

Pencils
Derwent watercolour pencils
 (used dry):
Flesh Pink 16
Burnt Sienna 62
Raw Umber 56
Light Blue 33
Copper Beech 61
French Grey 70
Burnt Umber 54
Ivory Black 67
Cedar Green 50
Gunmetal 69

Paper
Tracing paper
White cartridge (drawing) paper

Additional equipment
Pencil sharpener
Fine sandpaper (glass-paper) or
 emery board
Putty and plastic erasers
Tissues

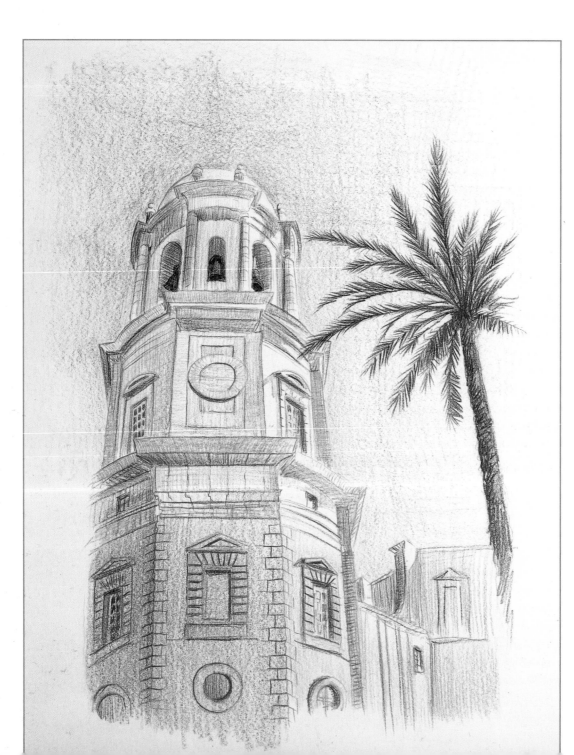

The support

Cartridge (drawing) paper is a good, cheap paper for drawing and sketching and it will also take a fair amount of eraser work. If you have a pad, keep the sheet you are working on in the pad. If you have a single sheet, tape it to a board with a few sheets of newspaper underneath.

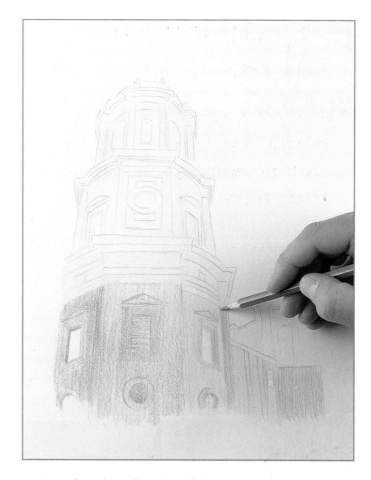

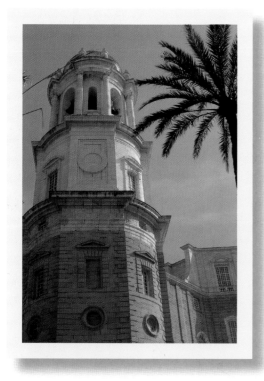

Reference photograph

In this photograph three sides of a hexagonal tower can be seen. In order to exaggerate the sense of roundness to the building, the side of the tower facing you will need to be lightened to achieve a progression from light to dark, rather than a jump from light to dark as in the photograph.

1 Trace down the outline using a light cream (Flesh Pink 16). It is very important with this particular subject to maintain the solidity of the structure, and you can do this by going back over the initial drawing as you work and shading with vertical pencil lines. Start by shading in the basic colour using the light cream for the upper part and a dark brown (Burnt Sienna 62) for the lower part of the building. Be careful not to go outside of the outline drawing. You can see the vertical pencil lines a lot clearer on the darker part of the drawing in this initial step. Once you have done that, you will need to sharpen the edges, especially in the lower, darker part of the building, because shading tends to soften and, sometimes, cover up the edges.

■ TIP: planning ahead

The blue sky in this drawing does not need to be done first. In fact, if you were to do it first, when you come to work on the building your hand will rub on the blue that you have already put down. Before starting a drawing look at the photograph and plan ahead to decide in what order things need to be done to avoid any smudging.

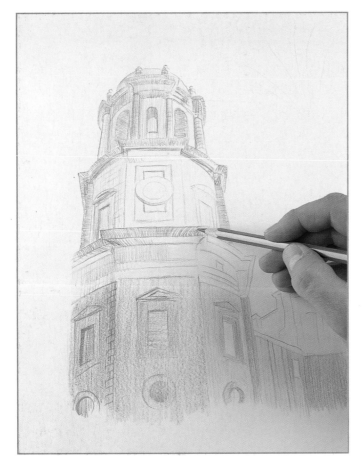

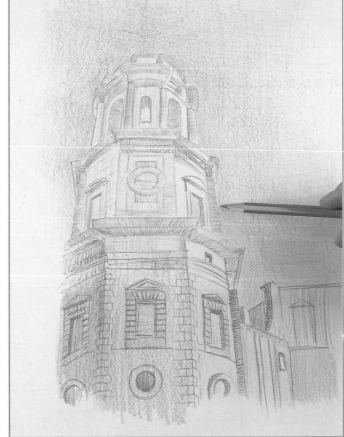

2 This step uses sharper and harder pencil lines to maintain the structure of the building. Using a darker brown (Raw Umber 56), start at the top of the picture and shade in the sides of the building using vertical pencil lines. Where the edges protrude from the building use a variety of lines to help give the impression that they are vertical and horizontal surfaces. On the top part of the building there are some circular columns. To achieve the roundness of these use circular pencil lines to establish the columns and shade in with a few vertical lines for the shadow. The left side of the building will need stronger and darker lines because it is in shadow. Finally, after sharpening your pencil, put in the edges of the bricks, making sure that you follow the angle of the perspective on the sides of the building.

3 Using a light blue (Light Blue 33) start to shade in the sky area. Try to work from the edge of the building out towards the edge of the paper, rather than in towards the building, to avoid overlapping the building with blue. You will not be able to achieve a strong blue with the first layer of colour, so once you have filled the space with the first layer turn the paper through 90 degrees and apply the same strength layer over the top. (See Shading in flat layers page 17.) You may need to do this two or three times to achieve the desired effect; however, do not try to replicate the strength of blue that you can see in the photograph.

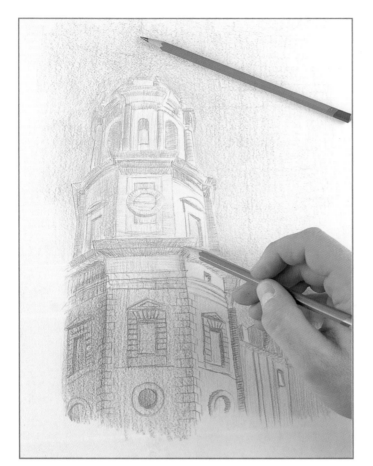

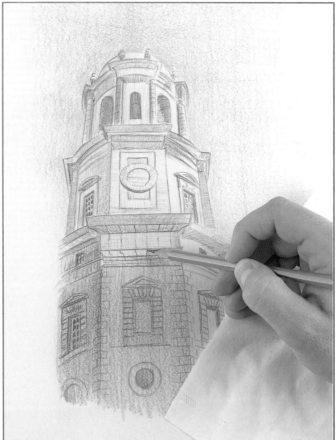

4 The completed blue sky will make the rest of the picture look a lot lighter. To compensate for this you will need to go back over the work that you have already done on the building. Using a darker, warmer brown (Copper Beech 61), shade vertically over the whole of the lower left and middle part of the building. Next, using a mid-tone grey (French Grey 70) do the same to the top left and middle sections of the building, including the shadows under the masonry that sticks out. This will darken and soften what was done previously. You can redefine the hard edges with a darker colour in the next step.

5 With a sharpened dark brown (Burnt Umber 54) put in the edges of the building where they have been softened due to previous shading. While you are working on this you can protect the parts of the work that may get smudged by placing a tissue over the parts of the drawing you are leaning on.

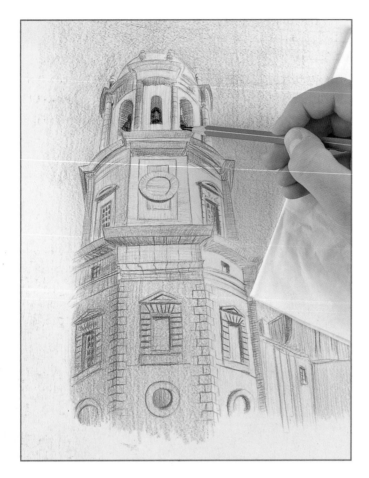

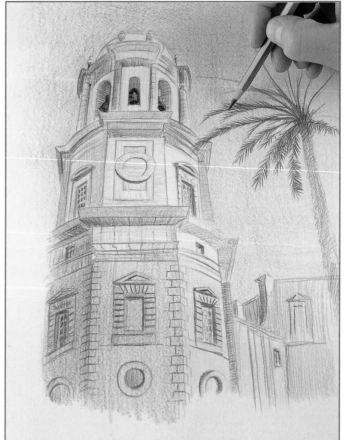

6 Start to put in the dark detail at the top of the building with a black pencil (Ivory Black 67). You can also strengthen some of the very dark shadow areas on the left of the building by lightly shading over with the black. Remember to keep shading vertically to emphasize the structure of the building.

■ TIP: sharpening the point
To maintain a sharp point without using a sharpener or a knife, use the sandpaper or an emery board to sand the pencil to a point. Wipe the excess dust from the end of the pencil with a tissue before returning to your drawing.

7 Using a dark green (Cedar Green 50), start to lightly shade in the palm tree. When you come to the leaves, start with the stem in order to position the leaf in the right place, then use the same flicking technique used for fur (see Tip page 99) to achieve the individual leaf fronds.

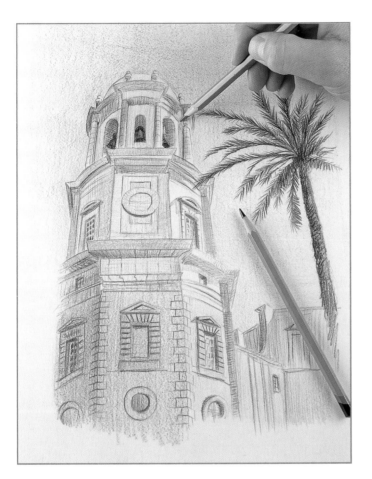

8 To give the palm tree more emphasis, go over the leaves and trunk with the black, leaving some of the green showing as a highlight. Finally, go back to the building and put in some of the shadows with a mid-tone grey (Gunmetal 69).

Technique check

There was a lot of work involved in this picture but you will have learned how to depict structure in a building with the clever use of directional shading or, in other words, shading with vertical pencil lines to depict a vertical surface. Try drawing different buildings at different angles and using a variety of colours.

A step further: a sense of scale

When drawing buildings, achieving a sense of scale is very important. The best way to do this is to put something in the picture with a size and shape that is easily recognizable and can be compared to the building. Figures are a good example. In this photograph there are very small figures on the bridge as well as a figure in the foreground. This picture will probably need a few more figures in the foreground, so look through your own photographs to see if they contain other figures you can use as reference. Remember that the figures that you put in will have to be roughly the same size as the figure that is already there.

LANDSCAPE

4 Townscape:
sketching techniques

One of the advantages of coloured pencils is their ease of use for sketching outdoors. All you need is a handful of pencils covering the basic colours and a sketch-pad. For this demonstration you will learn how to use the immediacy of the pencil to gather information and how to establish colour and form with the minimum of fuss, all techniques that will serve you well when sketching on location.

MATERIALS

Pencils: Derwent watercolour pencils (used dry): Burnt Yellow Ochre 60, Raw Sienna 58, Light Blue 33, Terracotta 64, Ivory Black 67, Blue Grey 68, Sap Green 49, Raw Umber 56, Gunmetal 69, Cedar Green 50, Indigo 36

Paper: White cartridge (drawing) paper

Additional equipment: Pencil sharpener, Fine sandpaper (glass-paper) or emery board, Plastic or putty eraser

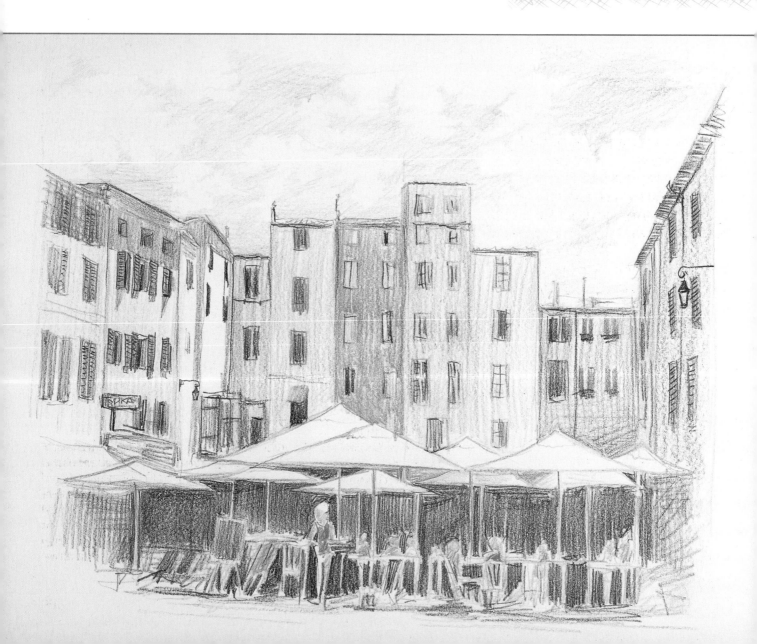

The support

Most sketch-pads contain good-quality white cartridge (drawing) paper, and some come with watercolour paper if you decide to use the pencils in combination with water.

Reference photograph

There seems to be a huge amount of detail in this picture, but the sketching technique will help cut out a lot of the work. The sky is a little flat and uninteresting so try to make it a more convincing summer sky.

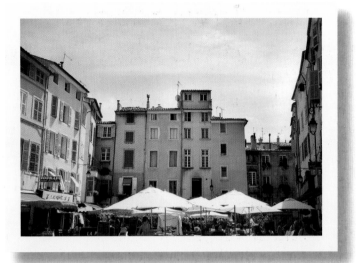

1 When sketching you do not want to rely on drawing aids, such as tracing down, to help with the initial outline. If you are not confident about drawing freehand, then use the Tracing down method (see page 22) to put in the basics, such as building shapes, positions and perspective. The rest can be put in freehand. Start with the buildings in the middle of the picture. Using a light brown (Burnt Yellow Ochre 60), put in the vertical lines and roof lines, paying particular attention to the fact that the buildings are not the same size and width. Next, put in the umbrella shapes and sketch in a few tables, chairs and figures underneath. Finally, roughly sketch in the buildings on both sides, making sure that the perspective is correct.

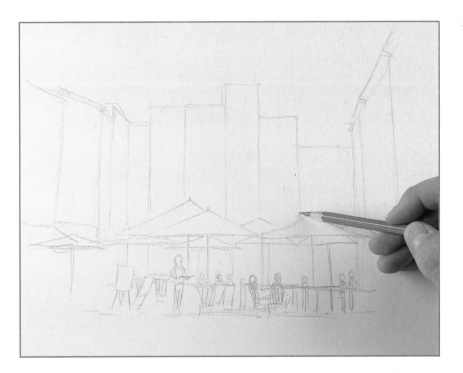

■ TIP: perspective

Perspective is the illusion of depth that objects and buildings give in a picture. The easiest way to explain perspective is to think of horizontal lines as they go away or recede from you, and whether they are above or below your eye line. To determine your eye line, hold a pencil horizontally level with your eyes at arm's length. Any horizontal line above your eye will slope down to your eye line as it recedes away from you. Any horizontal line below your eye will slope up to your eye line as it recedes away from you. The best way to reproduce the roof lines in this picture is to work from the eye line. There is a figure just to the left of centre, underneath the umbrella. The eye line will go right through her head from one side of the picture to the other, so all the buildings on the left and right will slope down as they recede away from you.

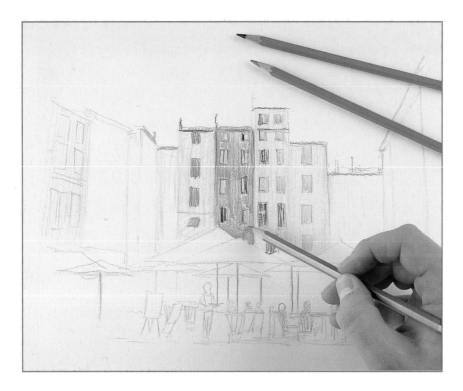

2 Once you are happy with the outline drawing of the buildings, start to shade in using different browns (Burnt Yellow Ochre 60, Raw Sienna 58). Even when sketching it is best to shade buildings in vertically to help convey the sense of structure, but do not be too rigid because you want to maintain a free and sketchy feel. At this stage you can start to put in some of the detail. Use a light blue (Light Blue 33) for the windows and a warm brown (Terracotta 64) for the roof edges. Add a few darker lines with black (Ivory Black 67) to give the picture some definition.

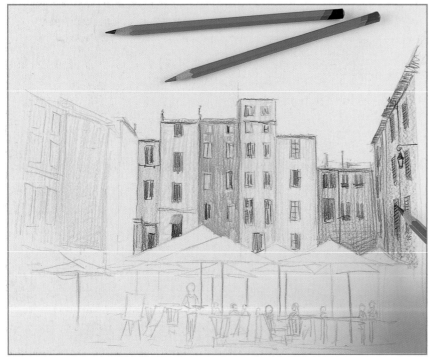

3 Continue to put in the buildings on the right. Where the buildings are in shadow, use darker colours such as light brown (Raw Umber 56) and blue grey (Blue Grey 68), and use the black to define some of the edges and windows. As before, try to shade in the pencil lines vertically to help establish the structure of the buildings. Move on to the buildings on the left and add in some light brown shading, but not too dark because these buildings have the sun on them.

4 Sketch in the windows on the left with a light green (Sap Green 49) and lightly outline them and other areas with the black. Use the blue grey (Blue Grey 68) to add in the shop sign. To emphasize the sunlight, put in the shadows using a mid-tone grey (Gunmetal 69). You may need to darken the buildings in the middle of the picture with the same grey.

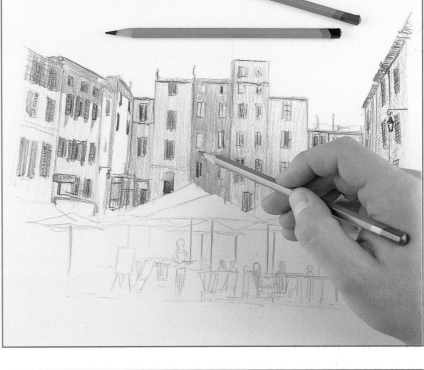

5 Use a light blue (Light Blue 33) to shade in the sky, leaving spaces for the white clouds. Lightly shade in the rough outlines of the clouds to begin with to give an idea of how they look before going back over them with heavier shading.

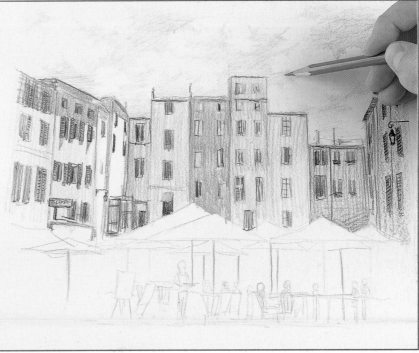

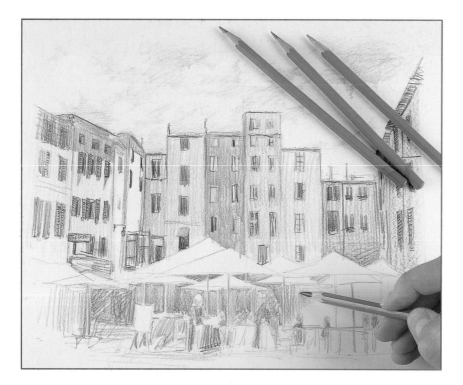

6 Most of the picture above the white umbrellas is finished now, so start to put in different areas of colour underneath, such as on the figures and furniture. Using a dark green (Cedar Green 50), start to block in the dark shadow areas. This will help with the sharp edges of the umbrellas. There is no need to apply too much pressure because you will be putting some darker colour over the top in the next step.

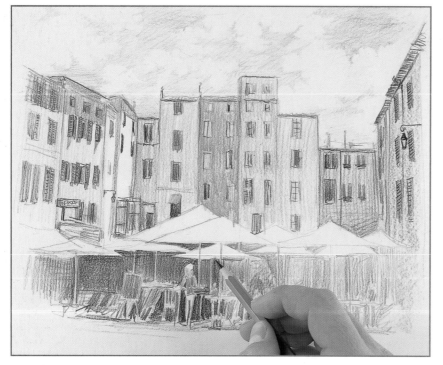

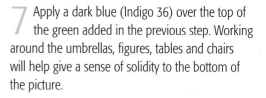

7 Apply a dark blue (Indigo 36) over the top of the green added in the previous step. Working around the umbrellas, figures, tables and chairs will help give a sense of solidity to the bottom of the picture.

8 Finally, define the edges of the umbrellas to make them stand out a little better. Use a sharp, mid-tone grey (Gunmetal 69) and lightly go back over the outlines of the umbrellas and any detail you can see, such as poles and shadows.

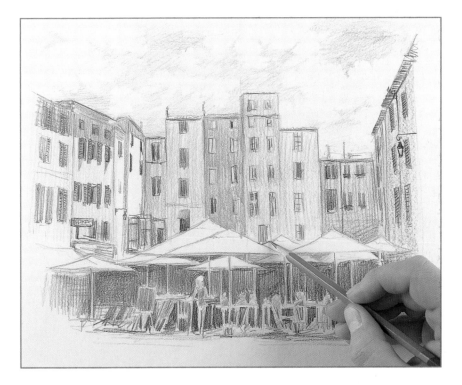

Technique check

This demonstration was similar in some ways to Landscape demonstration 1 (see pages 50–55), which dealt with different textures achievable with the pencil. However, in this demonstration most of the work dealt with line and colour, and especially with light and dark areas. When out sketching, try to concentrate on these areas, especially when sketching in towns and villages because the buildings need to have the feeling of structure without being too rigid and tight.

A step further: cropping, a picture within a picture

When considering your next project, look at your existing photographic reference. There is no need to reproduce everything that you see in the photograph so, by cropping certain areas, you can produce new drawings from photographs you have already used. The easiest way to do this is to cut two 'L' shapes from a piece of white card and use these to crop the photograph. Alternatively, if you have access to a computer you can do the same by using the cropping tool in any photo-editing software. An example of a cropped picture is shown here (right).

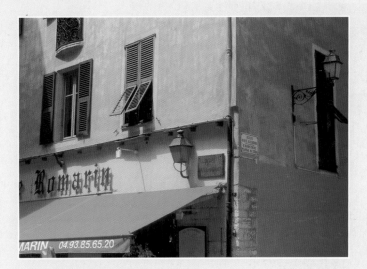

PEOPLE

1 Portrait:
skin tone, wet and dry

This demonstration shows you how to build up skin colour and tone using a combination of wet and dry techniques. You will also learn how to build up deep layers and leave out highlights.

MATERIALS

Pencils
Derwent watercolour pencils
 (used wet and dry):
Bronze 52
Blue Grey 68
Pale Vermillion 13
Straw Yellow 5
Silver Grey 71
Burnt Umber 54
Ivory Black 67
Golden Brown 59
Copper Beech 61
Chocolate 66
Olive Green 51
French Grey 70
Chinese White 72
Gunmetal 69

Paper
Tracing paper
White, smooth, 300gsm (140lb)
 watercolour paper

Additional equipment
Pencil sharpener
Fine sandpaper (glass-paper) or
 emery board
Plastic eraser
Size 4 or 6 round watercolour
 brush
Jam jar
Tissues

The support

In previous demonstrations that have used the wet pigment technique the recommended support was a not surface watercolour paper that has a texture to it. In this demonstration a smooth watercolour paper is used, which will enable you to lay down an initial wash of colour and then, when dry, work over the top with dry pencil. The smoothness of the paper allows for a more highly finished effect than would be achievable on a rougher surface.

Reference photograph

The obvious problem with this photograph is that the top of the sitter's head is cut off, so this area will need to be drawn in from imagination. Also, the light is hitting the front of the face and showing a lot of skin texture, but don't worry too much about this because the texture of the paper will help you produce the skin texture you require.

1 Trace down the outline of the head and shirt. When applying wet pigment to a drawing it is best to start light and work towards dark, especially on smooth paper where dark pigment can create too many brush marks. Starting with a light brown (Bronze 52) shade in a heavy area of pigment on a scrap piece of watercolour paper. You will need quite a lot of this so shade in an area approximately 8cm (3in) square. At this point you can also lay down some of the other colours for the initial part of the drawing, here a blue grey (Blue Grey 68), a salmon pink (Pale Vermillion 13) and a light yellow (Straw Yellow 5). Using a size 4 or 6 round watercolour brush, wet the patch of brown and start painting in the face and neck, leaving spaces for the highlights, eyes and lips. (See also Dissolving colour with water, page 21.)

Pick up some of the blue grey and paint in the beard area and the top lip. Paint in a small amount of the pink on the bottom lip. Finally, paint in the shirt using the light yellow.

■ TIP: using brush marks

On a smooth paper you can use brush marks to create structure and form. When painting the neck try to paint curved brush marks from the outside in towards the centre. This will help maintain the curvature of the neck.

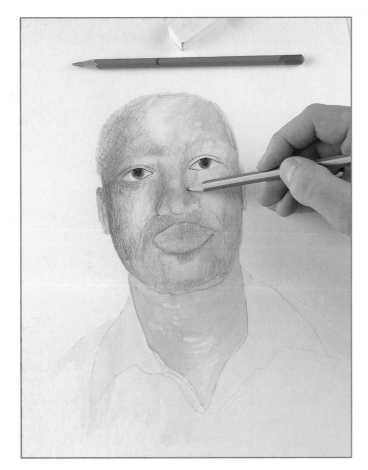

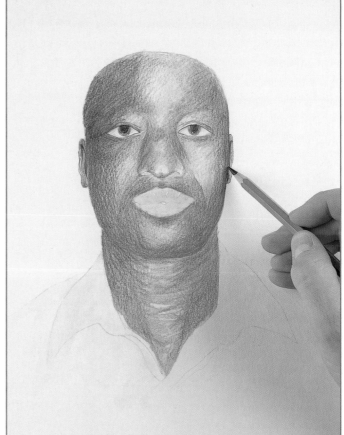

2 Clean the brush and touch the wet tip to a light grey (Silver Grey 71) pencil. Paint around the edges of the eyeball with the light grey to create the shadow thrown by the eyelids. Next, using the pencils dry, put in the iris with a dark brown (Burnt Umber 54) and finish off by putting in the pupil and eyelids with black (Ivory Black 67). You can put the highlights in with a wet white pencil later. At this stage the eyes look very strong because of the contrast with the skin colour done so far. So start to build up the skin colour, using dry pencils, with light and mid-tone browns (Golden Brown 59, Copper Beech 61). Try to work around the highlighted areas but don't worry if you start to fill them in because you can take out and soften these highlights with an eraser.

3 Once you have used the lighter browns to start building up the skin tone, move on to a darker brown (Chocolate 66) for the richer, darker areas of the face. Do not try to get the strong colour down in one layer because you may clog the paper up with too much pigment. Use the dark brown to shade in as many layers as it takes to achieve the correct strength of colour. Try to do each successive layer at a different angle to the previous one to soften the pencil lines. Use curved pencil lines on the neck as you did with the brush.

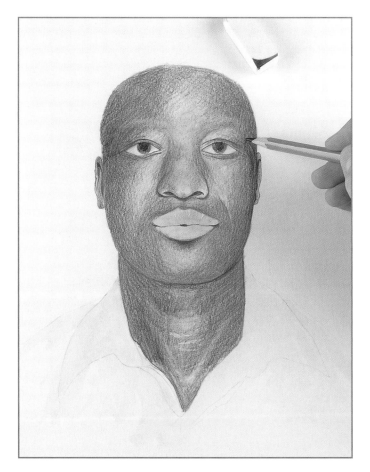

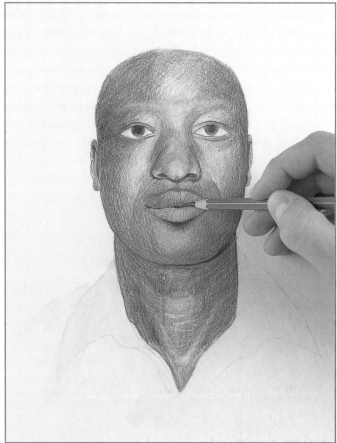

4 Continue to strengthen the skin with the darker brown (Chocolate 66) and also, with a sharpened pencil, try to re-establish the outline that tends to soften with excessive shading. Once you have used the darker brown as much as you can, use a plastic eraser to rub out some of the highlights on the face and neck. Do not press too hard as this may produce a light line. Use the dark brown to define the nostrils and the mouth line.

5 Start to build up the mouth with a blue grey (Blue Grey 68), warm, yellow brown (Golden Brown 59) and dark brown (Chocolate 66). These are the same colours as used on the face. Make sure the lighter hard lines follow the contours of the lips. You can put the strong highlights in later with some wet white pigment.

■ **TIP: drawing a mouth**
When drawing a mouth, especially when looking at it face-on as in this demonstration, the top lip will appear darker than the bottom lip. Also, the bottom lip tends to be pinker and will throw a shadow onto the chin below it.

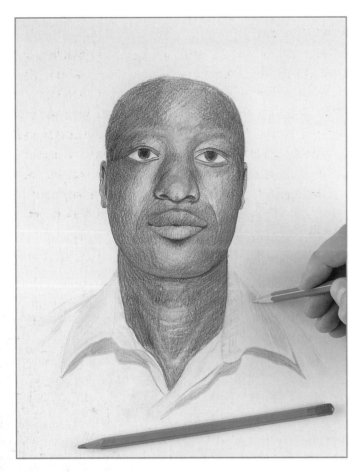

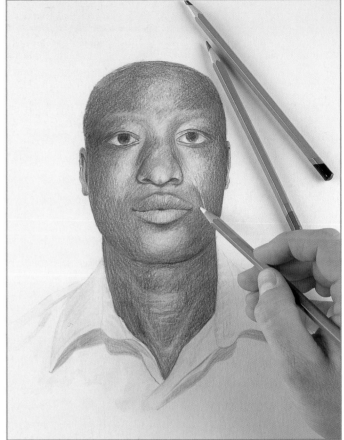

6 It is now time to start work on the shoulders. Using a dark, warm green (Olive Green 51), shade in the shadow underneath the collar. Pay particular attention to the way the shadow follows the contour of the shirt. Next, using a light, warm grey (French Grey 70) lightly shade in the shadow on the left collar and near the neckline.

7 Go back to the face and use a white pencil (Chinese White 72) to softly blend in all the skin tones you have put down. Try to avoid the highlighted areas because white is difficult to erase. Next, using a dark brown (Chocolate 66), darken the sides of the face and neck where the white has lightened it. Finally, use a dark grey (Gunmetal 69) to tint the whites of the eyes slightly since they now look too bright.

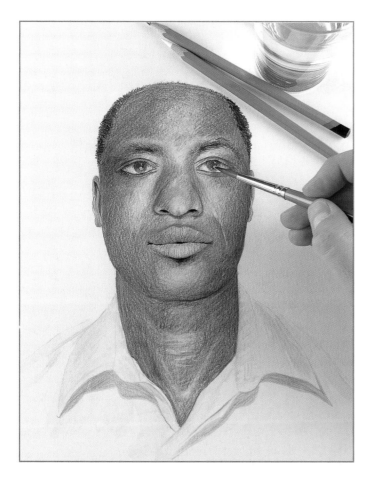

8 Using a sharp black pencil, start to flick in the eyebrows and some of the eye lashes. Also, use the black to put in the hair, made up of very small, tight circles and curls. Finally, using some wet white pigment picked from the end of the white pencil with the brush, put in the highlights in the eyes and on the mouth.

■ TIP: scratching out
Another way of putting in the highlights in the eyes is to scratch them out with a sharp knife. However, be careful as this may create a hole in your support if done too heavily.

Technique check
This particular subject was chosen because of the amount of colour involved. During this demonstration you were shown how to build up the correct strength of colour with lots of layers, rather than trying to achieve it with only a few. The initial wet washes were an important start to this drawing because they gave a good indication of how the drawing would eventually look and saved a lot of work with the dry pencil. You were also shown how to work around and leave out the highlights. These are vitally important in any picture and, by planning ahead, you were able to achieve a sense of form even when looking at someone's portrait face-on.

A step further: hair
The most important thing to remember about drawing hair is to maintain the direction that the hair is growing in by using a sharp pencil. In this photograph the hair curls up at the front and is combed over the top of the head and down, around the ears. If you are drawing onto a white support you will need to indicate the lighter parts of the hair by drawing in the darker hairs around them. In some cases there are small, light hairs surrounded by large dark areas. Try to keep these as sharp as possible to help give the feeling of combed hair. Where the hair

overlaps the skin tones, especially over the ear, it is a good idea to work the skin tones first and add the hair over the top. Try not to put in too hard a line where these two areas overlap because it will be difficult to disguise.

PEODLE

2

Hand:
achieving realism

The preceding demonstration discussed how to apply colour using a combination of wet and dry. Another way to achieve a sense of realism, however, is to apply layers of dry colour. This demonstration will guide you through the process of layering from light to dark and also show you how to achieve realistic skin texture and tone by using a limited number of coloured pencils.

MATERIALS

Pencils: Derwent watercolour pencils (used dry): Burnt Sienna 62, Raw Sienna 58, Crimson Lake 20, Chinese White 72, Burnt Umber 54, Blue Grey 68

Paper: Tracing paper (optional), White, smooth, 300gsm (140lb) watercolour paper

Additional equipment: Pencil sharpener, Fine sandpaper (glass-paper) or emery board, Plastic and putty erasers

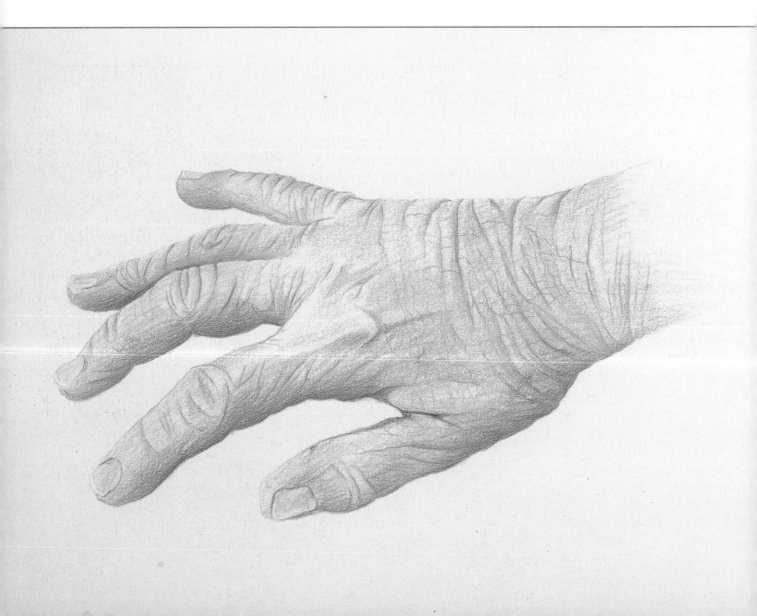

The support

Smooth watercolour paper has a wonderful feel to it; however, because it is paper and not mount (museum) board, you will have to be careful not to work too hard when applying the colour. Eight light layers are better than four heavy ones.

Reference photograph

Light direction in any picture is important and especially so in this photograph. When ascertaining the direction of the light, look at the shadows. In this photograph the shadows are below the hand, therefore, the light is coming from above. Also, there is a double shadow in the photograph because there are two light sources. In your drawing you will need only one shadow, so choose the lighter one. You do not have to decide, at this stage, whether or not to include the second shadow. You can make this decision when you have completed the picture.

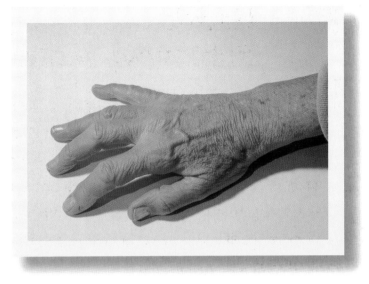

1 Use a burnt sienna (Burnt Sienna 62) to draw or trace down the outline, making sure you include all the lumps and bumps caused by the wrinkles meeting the edge of the hand. Using the same pencil, start to shade in, being careful not to press too hard. You want to achieve a fairly even colour without too many pencil lines showing. Once this is achieved start to press a little heavier to darken underneath the fingers.

■ TIP: pencil too sharp

In order to achieve a fairly even layer of colour it is best not to have the pencil too sharp. After sharpening the pencil to a point gently rub it from side to side a few times on some fine sandpaper (glass-paper) or an emery board to produce a small, flat surface on the end of the pencil. Use this flat spot to shade in the colour.

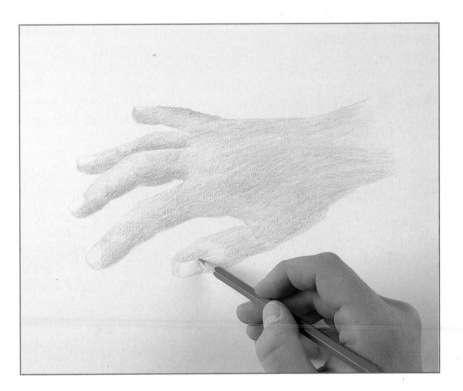

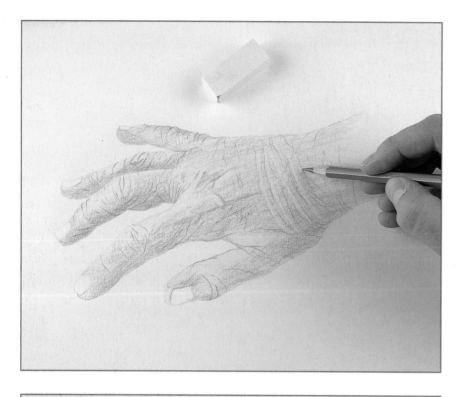

2 Once the hand is shaded in, use an eraser to rub out some of the larger, highlighted areas, especially on the tops of the fingers. (See Rubbing out and lifting off page 19.) Next, using the same brown (Burnt Sienna 62), start to put in the wrinkle lines. You will need to keep the pencil sharp for this so have a pencil sharpener and fine sandpaper (glass-paper) or an emery board close by. Try to follow the contours of the hand and fingers when putting in each, individual line and vary the length and thickness to create a more natural look. Notice that the lines thin out where they run into the highlighted areas.

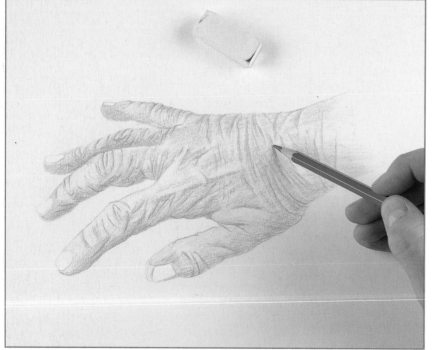

3 Use the same brown (Burnt Sienna 62) to shade in the darker edge of each wrinkle. In this picture the light is coming from the left so the darker side of the wrinkle will be on the left of the next wrinkle line. This shading will take time to complete but as you do it the hand will start to take on a more realistic look. When you have finished, use the eraser to rub out some of the highlights.

4 Using a light yellow brown (Raw Sienna 58) shade over the back of the hand to yellow the skin slightly. After you have done this you will need to put the wrinkles back in with the burnt sienna (Burnt Sienna 62), but first you must rub out some of the highlights again. You will be drawing a lot of the wrinkles like this so don't worry about rubbing anything out because you can always put it back in. Finally, use the burnt sienna to put in some fine wrinkles at 90 degrees to the original ones on the back of the hand, and start to darken the edge of the hand at the bottom by applying more pressure.

■ TIP: going over wrinkles

When drawing a line that goes over a wrinkle at a different angle, remember to follow the contour of the fold in the skin. Have a close look at the back of the hand where this has been done. In between each wrinkle line the skin bulges up, so the line that crosses this must also curve up and then down the other side.

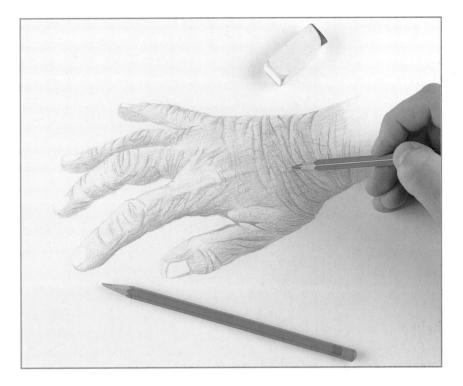

5 Using the burnt sienna (Burnt Sienna 62), apply the same pressure to darken the edges of the fingers. When you have done this use a dark, pinkish red (Crimson Lake 20) to shade in the pink parts of the fingers, mainly at the tips. Lightly shade over the highlighted areas of the fingers to lessen the contrast.

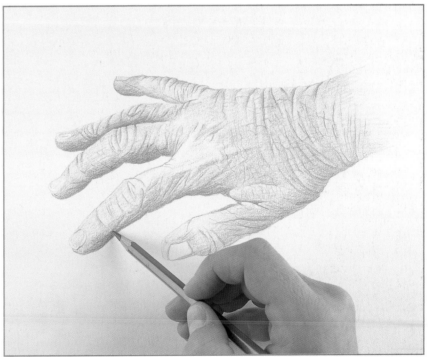

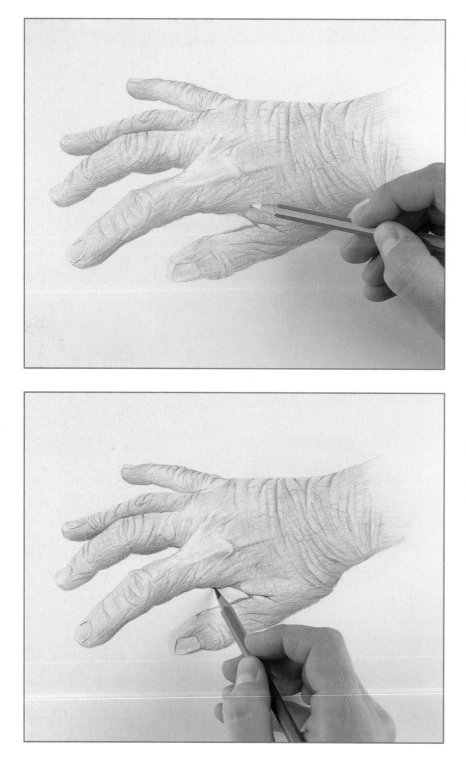

6 In order to maintain the realistic effect you will need to soften most of the pencil lines. Use white (Chinese White 72) to shade over all of the work you have done so far. This burnishing will soften the pencil lines and, in some places, blend the colours together. (See Burnishing page 18.) You do not need to apply too much pressure.

7 Most of the work so far has been done with warm browns and reds. Now use a darker brown (Burnt Umber 54) to increase the strength of the shadows at the bottom edges of the fingers and hand. Use the same brown to emphasize the fingernails and some of the larger wrinkles.

8 One of the problems with using a brown for the darker parts of the drawing is that it can appear to be too warm, so use a cool blue grey (Blue Grey 68) to shade in the darker areas on the edges of the fingers and hand. This will give a cooler and more comfortable shadow effect. This picture does not need to have the underlying shadow put in because it would detract from all the hard work done on the hand itself.

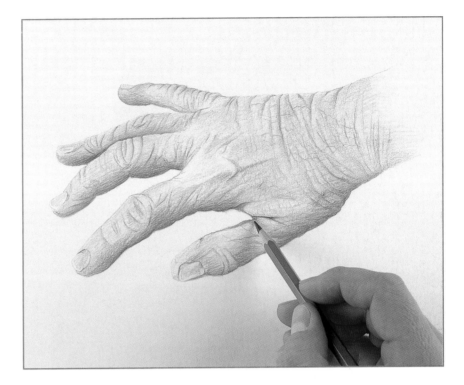

Technique check

Achieving a sense of realism is hard enough, but achieving realistic skin tones in the same picture means a lot of hard work for your eyes as well as your pencils. This demonstration has shown how to build up the skin tones and texture slowly and how to draw wrinkles realistically using a limited number of colours. It has also illustrated how important it is to look at each wrinkle and draw and shade each one separately, rather than treating them as a group.

A step further: contrasting surfaces

Sometimes a picture can benefit from the effects of contrasting surfaces. The hands here have a rough, wrinkled texture to them, which is contrasted against the smooth, hard surface of the coffee mug. Also, concentrating on a hand on its own, as in the main demonstration, can be a little dull, so giving the hand something to do can make your picture more interesting. Try experimenting with the hand holding various items, such as pens, paintbrushes or flowers.

PEOPLE

3 Child's face: subtle shading

Children are one of the most difficult subjects to draw. You need to use the coloured pencil in light, delicate layers of shading in order to achieve their subtle skin colour and texture. This demonstration will show you how to achieve the best results using dry pencil shading and also how to use your eraser as a drawing tool to pick out the lighter areas of the face.

MATERIALS

Pencils: Derwent watercolour pencils (used dry): Pink Madder Lake 17, Smalt Blue 30, Ivory Black 67, French Grey 70, Bronze 52, Terracotta 64, Gunmetal 69, Raw Umber 56, Venetian Red 63, Blue Grey 68, May Green 48, Straw Yellow 5, Rose Madder Lake 21, Crimson Lake 20, Burnt Umber 54

Paper: Tracing paper, White cartridge (drawing) paper

Additional equipment: Pencil sharpener, Fine sandpaper (glass-paper) or emery board, Putty eraser

The support

Any good, smooth, white paper is suitable for this particular exercise. White cartridge (drawing) paper is cheap and readily available from most outlets, in both sheet and pad format.

Reference photograph

All you need to concentrate on for this demonstration is the head and shoulders of the girl and the soft toy that she is resting her head on. The background details, including the table, can be left out. Try not to put too much colour and detail into the pink pullover and the patterned dress because they will detract from the face.

1 Use a light pink (Pink Madder Lake 17) to trace down the outline. As with Portrait demonstration 1 (see pages 74–79), do as much to the eyes as you can to help you decide, later on, when the picture is finished. Using a sharpened light blue (Smalt Blue 30) gently shade in each iris, working from the outside in towards the middle so that the iris is darker at the edge. Next, using black (Ivory Black 67), put in the pupil, leaving a small white spot for the highlight. Use the black to put in the edges of the eyelids and flick in some small eye lashes. At this point the white of the eyeball looks too bright so use a mid-tone grey (French Grey 70) to lightly shade over it, making it slightly stronger where it meets the eyelid. Once you have done this, start to shade in the skin tone using the light pink. Start with very light shading and build up the darker areas by applying more pressure with the pencil.

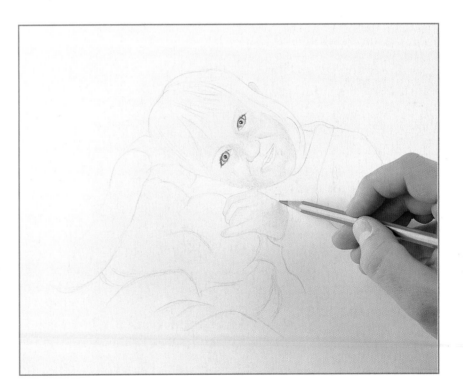

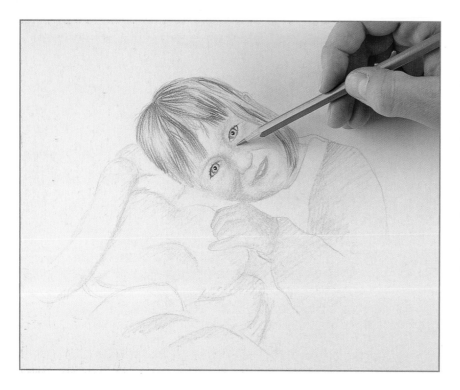

2 Before advancing any further with the skin tone, start to put in the hair using a mid-tone brown (Bronze 52). Try to use the sharp pencil lines to draw in the direction that the hair is growing. The lighter, highlighted areas will be depicted by the white of the paper, so thin out the pencil lines in these areas. Next, using light, soft pencil lines, put in a warmer skin colour using a warm light brown (Terracotta 64) and working around the highlights. Soften the edges of the highlights with a putty eraser. Start to put in the lips with a warm pink (Pink Madder Lake 17) and use this pencil to start to shade in the pullover. Use a grey (Gunmetal 69) to define the soft toy.

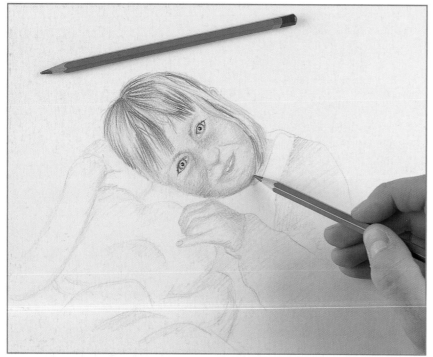

3 You can now strengthen the girl's face with stronger colours. Take a light brown (Raw Umber 56) and a reddish brown (Venetian Red 63) and use light layers of each to slowly build up some of the darker areas of the face and hand. Work around the highlighted areas but do not worry if you make the highlights look smaller because you can put these back in by rubbing back with the eraser.

4 At this stage there is a lot of contrast between the face and the rest of the drawing, so this step concentrates on building up the soft toy and the girl's clothes. Using a dark grey (Blue Grey 68) and a warm grey (French Grey 70) sketch in the soft toy. Next, use light green (May Green 48), light yellow (Straw Yellow 5) and deep pink (Rose Madder Lake 21) to roughly sketch in the clothes. You do not need to do any highly finished work on these parts of the drawing because they will detract from the face.

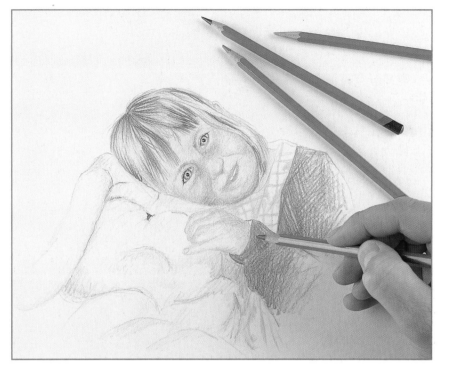

5 Moving back to the face and hand, choose a warm, pinkish red (Crimson Lake 20) and start to warm up the darker parts. Again, try not to apply too much pressure straight away. Use a putty eraser to rub out the highlights.

■ **TIP: clean eraser**
Keep your eraser as clean as possible as any colour left on it will transfer to the part of the drawing that you are rubbing out.

6 Using a sharp dark brown (Burnt Umber 54), darken the hair using pencil lines that follow the contours of the head and the pencil lines that you have already put down. Try to keep some of the highlights by leaving gaps between the pencil lines.

7 Use the same dark brown to outline the face and hand, and to shade in the shadow under the arm.

8 Some parts of the face need to be adjusted slightly with the warm, pinkish red (Crimson Lake 20) used previously. Use it lightly in just a few places, such as on the cheeks and chin, remembering to reserve the highlights.

Technique check

A child's face is one of the most difficult subjects to draw because it does not have any wrinkles or lines to help you achieve a likeness and character. This demonstration showed you how to build up delicate shades of colours and how to lift out highlights using an eraser. There is a lot more work involved with the face and hands than on the soft toy and the girl's clothes, because the face and hands are the important part of the picture. The next time you look at portrait paintings and drawings see if you can notice this in other people's work.

A step further: babies' faces

Having completed the child's face demonstration you can now appreciate how difficult it is to achieve a likeness. Once mastered, however, drawing children is most rewarding. A more advanced subject would be to attempt the face of a child even younger than the previous one. This particular photograph is of a child approximately one to two years old and, as you can see, the skin texture and tone is even softer than that of the demonstration subject. One thing that does help is the strong light source. This has cast a dark shadow on the left side of the face and also down the nose and chin, giving you a better chance of reproducing a three-dimensional effect. When taking your own photographs try to get the child to stand to the side of a strong light source, such as sunlight streaming through a window. The other alternative is to use professional photographs, such as school photographs, that use high-quality lighting.

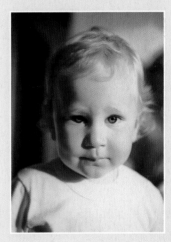

PEOPLE

4 Mature face: working on a dark background

Old people's faces have a lot of character in them. One way to reproduce this character and incorporate a sense of mood and atmosphere is to do the drawing on a dark background. This demonstration shows how to choose and apply the right colours and how to achieve skin texture and form by the careful use and overlaying of light and dark colours.

MATERIALS

Pencils: Derwent watercolour pencils (used dry): Ivory Black 67, Chinese White 72, Flesh Pink 16, Cedar Green 50, Burnt Umber 54, Pale Vermillion 13, Raw Sienna 58, Turquoise Green 40, Gunmetal 69, Crimson Lake 20, Burnt Yellow Ochre 60

Soft white pencil (optional)

Paper and board: Tracing paper, Dark grey mount (museum) board

Additional equipment: Pencil sharpener, Fine sandpaper (glass-paper) or emery board, Plastic eraser

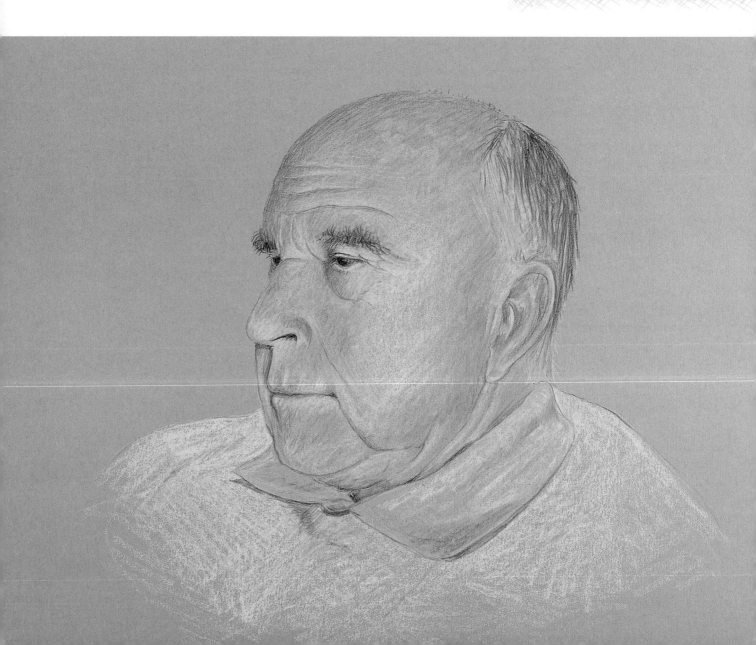

The support

If you have trouble choosing the colour of board or paper to work on, try a dark or mid-tone grey. Most of the greys available are what are called 'neutral'. This means that they are compatible with most other colours.

Reference photograph

This photograph was taken using a flash. The problem with flash is that it floods the subject with so much light that it flattens the shadows, especially on the wrinkles in the face. Therefore you will need to look closely at the light and dark areas and exaggerate them in your drawing.

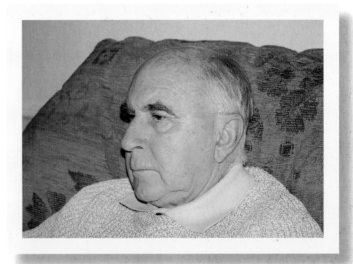

1 Trace down the outline in black (Ivory Black 67) and re-emphasize it with a lighter pencil such as a white (Chinese White 72). Next, using light pink (Flesh Pink 16), start to shade in the top of the head and around the eyes. Do not go all over the head because you will lose a lot of the outlines. Put in the eyes almost to a finish, starting with white for the eyeball, then mid-tone green (Cedar Green 50) for the iris and finishing with black for the pupil. At this stage the picture looks a little odd so you will need to redefine the areas around the eyes with stronger, darker colours. Use a dark brown (Burnt Umber 54) for the eyelids and shading under the eyes and white for the lighter areas to start to build up the form. Finally, go back over the top and left side of the head with a darker pink (Pale Vermillion 13).

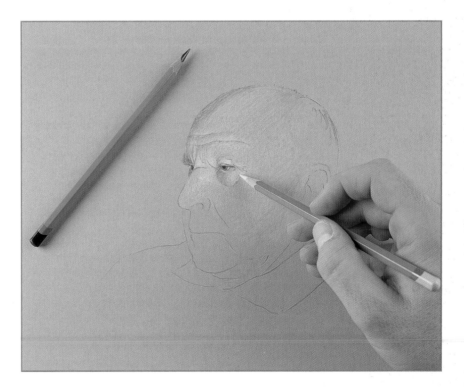

■ TIP: wrinkles

When putting in wrinkles there is a temptation to draw them in as a simple line, but there is more to them than that. Using the dark brown (Burnt Umber 54) draw in the wrinkles you can see running horizontally across the forehead, remembering to follow the contours of the head. Next, using the white, shade in just above the wrinkle where the light (coming from the right) is catching the underneath of the fold of skin.

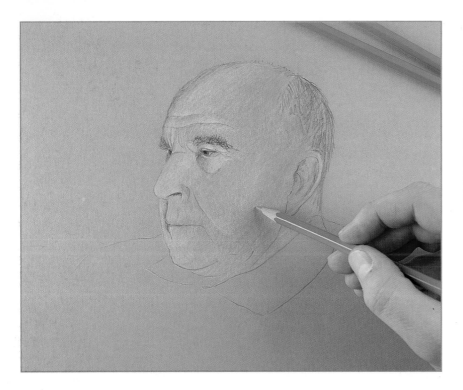

2 Start to build up the skin colour using a pale pink (Flesh Pink 16), going back over some of the shading you have already done. Next, warm up this colour in places using a warmer pink (Pale Vermillion 13) and a warm light brown (Raw Sienna 58). After all this shading you will need to redefine some of the sharper edges such as eyebrows, nose and ear. Do this with a dark brown (Burnt Umber 54) but do not make these lines too sharp. Start to lightly shade in the hair with the black.

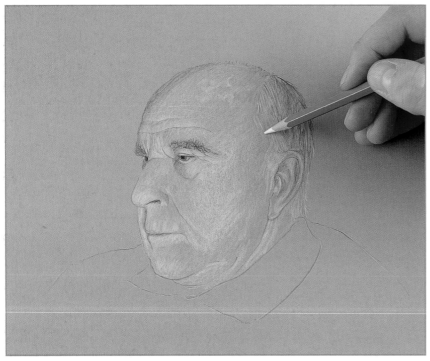

3 You will need to build up the lighter areas of the drawing since it is still looking a little dark and flat in places. Using the white, start to shade the lighter areas of the face, such as in between the eye and ear and also on the mouth and chin. Apply more pressure, or use a softer white pencil to put in some of the stronger highlights around the eye and on the ear. Also put in some white lines for the grey hair.

4 To balance the work done on the head roughly
sketch in the shoulders. Using a light blue
(Turquoise Green 40), shade in the shirt collar
and use the white to put in the highlights. A dark
grey (Gunmetal 69) can be used to shade in the
soft shadows. Use the white to shade in the area
of the shoulders, fading off as you move away
from the head.

■ **TIP: fading out**
As you work on the shoulders and collar try not to overdo
the colour and texture. The important part of the picture
is the face. Any excessive work anywhere else will detract
from the work done on the head.

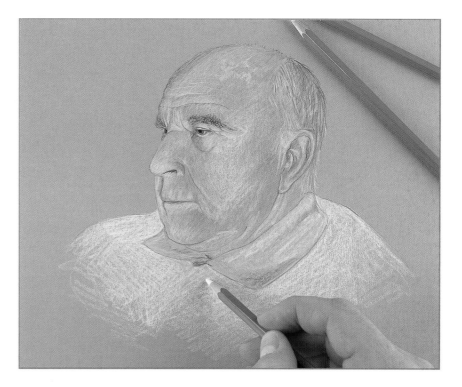

5 Going back to the face, use a warm, pinkish
red (Crimson Lake 20) to build up the pink
areas of the face. Use this in combination with the
white to burnish the pink areas so they do not look
too garish. Do not apply too much pressure with
the pink pencil because this will make it difficult to
burnish with the white. (See Burnishing page 18.)

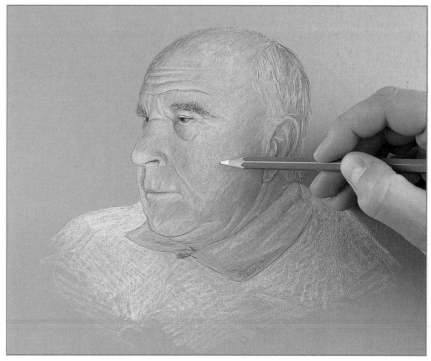

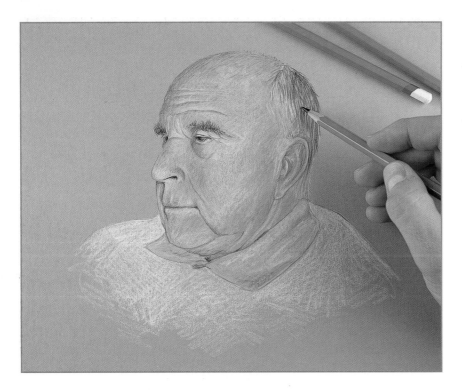

6 With a dark grey (Gunmetal 69) start to shade in some of the shadow areas, such as around the eye, under the chin and on the left side of the head. Next, put in detail in the hair, eyebrows and mouth area with the black. When you have done the hair use the white to soften and grey it slightly.

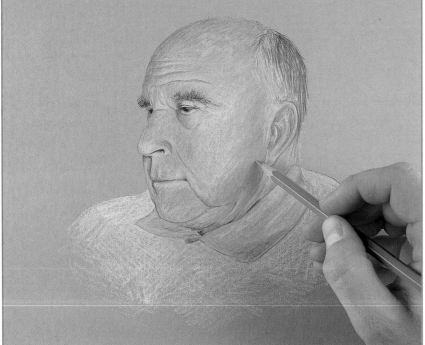

7 The pink in the face needs to be balanced with a warmer colour. Choose a warm, yellow brown (Burnt Yellow Ochre 60) and lightly shade in the face around the eyes, nose and across the forehead.

8 Finally, use a mid-tone grey (Gunmetal 69) to darken some of the shadow areas on the face and under the collar. After sharpening the pencil put in a few light wrinkle lines under the eye to add that final touch of character.

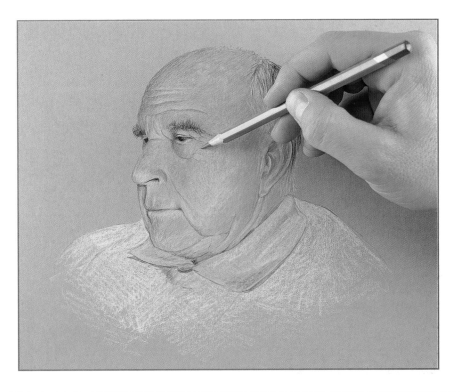

Technique check

The dark grey background has given this drawing a feel that would not have been so easily achievable on a white support. The colour of the board works well with the colours that were used in the drawing of the face. Mount board also allows you to work a lot of layers on the surface and will take a lot of erasing and scratching out.

A step further: monotone from colour

Monotone is the term given to pictures that are completely devoid of colour; in other words pictures that concentrate entirely on the light and dark. Just as black-and-white photographs have a particular atmosphere and feel to them that is quite different to a colour photograph, so do monotone drawings and paintings. However, you do not have to restrict yourself to just using grey, black and white. You could do a sepia drawing using shades of brown instead. If you

have access to a computer you can scan in a colour photograph and convert it to a sepia picture to work from. If working with brown and white it is a good idea to work on a light brown or cream support.

ANIMALS

1 Cat's eyes: eyes and fur

This demonstration will give you the opportunity to practise elements of drawing that are vitally important when drawing animals, especially pet portraits. The eyes of any animal, including pets and people, give life and character to a picture. This exercise will show you how to achieve lifelike eyes using highlights and delicate shading, and show you how to achieve realistic fur close-up.

MATERIALS

Pencils: Derwent watercolour pencils (used dry): Ivory Black 67, Raw Sienna 58, French Grey 70, Water Green 44, Juniper Green 42, Gunmetal 69, Cedar Green 50, Sepia 53

Paper: Tracing paper, Smooth, white cartridge (drawing) paper

Additional equipment: Pencil sharpener, Fine sandpaper (glass-paper) or emery board, Plastic eraser

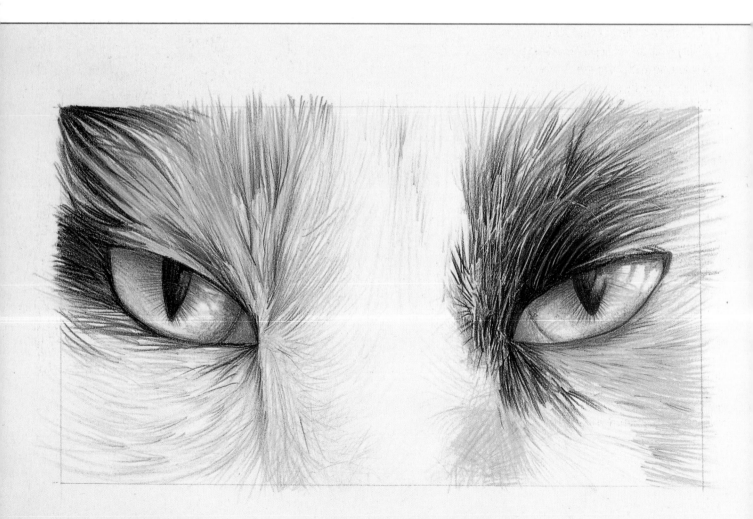

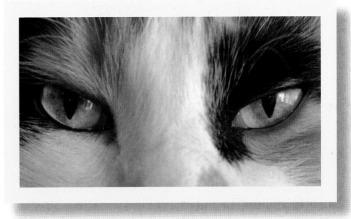

The support

A very smooth, white cartridge (drawing) paper has been chosen for this demonstration because of the delicate shading required in the eyes. An ordinary, standard cartridge (drawing) paper or even a smooth watercolour paper could also be used.

Reference photograph

This photograph was taken by a professional photographer using specialist equipment to get in close to the cat's eyes. If you can't get a good enough photograph with your own camera look at photographs in magazines or books or from photo libraries on the Internet. You can use these sources of reference for practising your drawing techniques but you must not use them for financial or commercial gain without the copyright holder's permission.

1 Trace down or draw in the outline in black (Ivory Black 67). To begin the detailing, use the incising technique to put in some of the longer white hairs above the eyes, especially the right eye. To do this use a hard, thin edge, such as a fingernail or the back edge of a knife, to incise grooves into the paper. You will be able to see them once you start to apply the color at the end of this step. (See Incising thin highlights page 20.) Start to put in the fur colour using a raw sienna (Raw Sienna 58), warm grey (French Grey 70) and black, working over the incised lines. Also, while using the black, start to put in the pupils and edge of the eyelids. Next, using a light blue green (Water Green 44), shade in the coloured iris in each eye, remembering to leave the highlights as white paper.

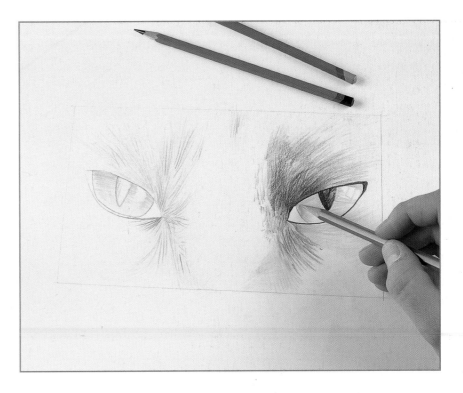

■ TIP: follow the fur

When putting in the fur, make sure that you follow the direction in which the fur is growing. Use a sharp pencil to flick in the long and short hairs. It is usually easier to flick towards you rather than away, which can mean you have to work some areas with the drawing upside down.

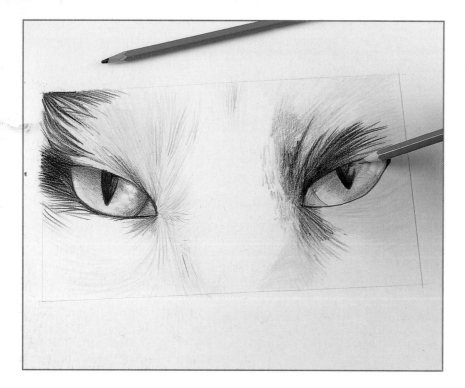

2 Using a darker green (Juniper Green 42), put in the darker areas of the eye working around the highlights using soft pencil strokes and overlapping the black pupil. Use a dark grey (Gunmetal 69) to put in the eyelid shadows and the corner of the eye, and the black to go back over the pupil.

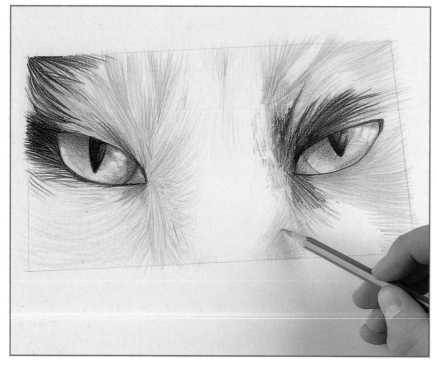

3 At this stage the eyes look a lot stronger than the rest of the picture so, in order to balance the drawing, start to build up the fur around the eyes. Using the same brown (Raw Sienna 58) and grey (French Grey 70) as in Step 1, build up the fur using the flicking technique (see Tip page 99). Overlapping the black in places will help to blend some of the colours together.

4 Going back to the eyes, choose a darker green (Cedar Green 50) and start to darken the edge of the eyes where they meet the eye socket. Also, using the same, sharpened green pencil, start to flick some green lines radiating out from the centre of the black pupil. Remember to work around the highlights. Finally, go back over some of the grey pencil to redefine the edges.

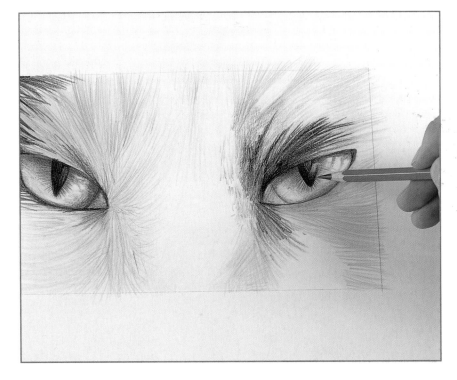

5 In Step 1 you incised grooves into the paper to depict some of the white hairs above the eyes. Some of these should be showing following the shading that you have already done. Using a sharp black pencil, start to shade in between these white lines to emphasize them and use the flicking technique as you move away from them.

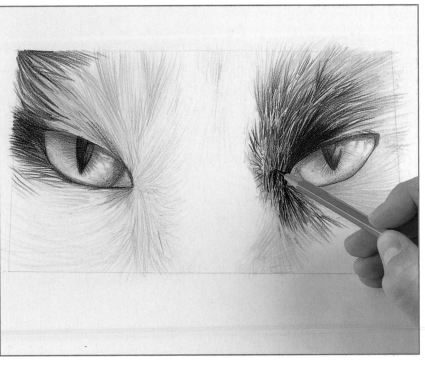

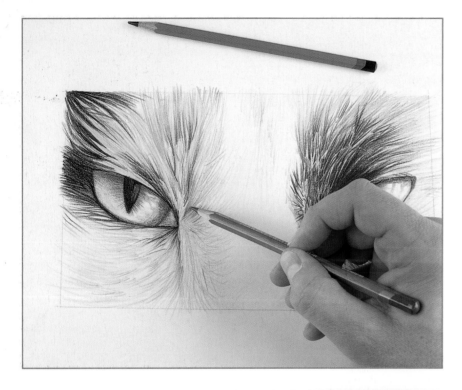

6 Move across to the left eye and continue to use the black to strengthen the black fur. Use a dark grey (Gunmetal 69) to flick in the fur on the left side of the nose, varying the pressure to achieve a variety of grey hairs.

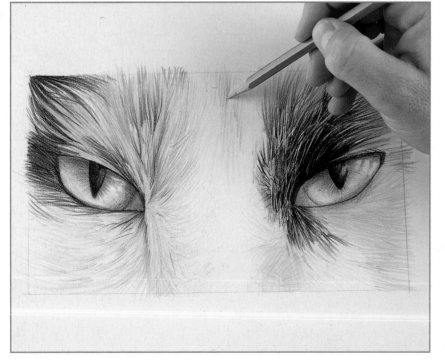

7 Draw in the softer, lighter fur with a lighter grey (French Grey 70), using the same technique as in the previous step. You can also overlap the black and light brown in places to soften the harder fur lines.

8 Now use a cool, dark brown (Sepia 53) to put in some of the lighter fur lines under the eye on the right. Do not apply too much pressure otherwise these lines will appear too dark.

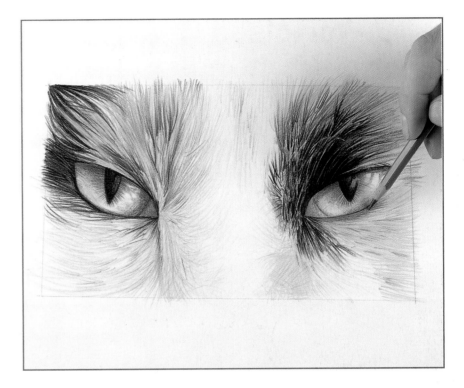

Technique check

This was a good exercise in how to draw eyes and how to achieve the look by leaving space for highlights. This particular technique can be used when drawing the eyes of other animals, including birds and people. This was also a good exercise on how to draw fur because you were working close-up. Try to remember what you did during this demonstration when working on the other drawings in the book that include fur.

A step further: other eyes

It can be a very useful practice to draw various other eyes. Ask a family member or friend to pose for a photograph. Ask them to look away from the camera (over your shoulder) to avoid red-eye. Colour magazines and books are also a helpful source of reference because the photographs in them have been taken using good lenses. Remember, however, that you cannot use them for financial gain without the copyright holder's permission, so only use them for practice. If you have a good camera yourself you can get close-up photographs of

birds of prey at any of the bird sanctuaries around the country, as was done with this picture. Birds of prey, such as this owl, have incredible eyes that also give a good reflection to work into your picture. If you can get close enough it is possible, sometimes, to see a mini landscape reflected in their eyes.

ANIMALS

2 Tortoise: burnishing colour

Certain surfaces and textures can be achieved by using the pencils in a particular way. This demonstration uses the technique of burnishing to reproduce the smooth, hard skin texture of the tortoise and how it can also change or influence a colour that has already been used.

MATERIALS

Pencils: Derwent watercolour pencils (used dry): French Grey 70, Straw Yellow 5, Blue Grey 68, Ivory Black 67, Chinese White 72, Gunmetal 69, Juniper Green 42, Gold 3, Raw Sienna 58

Soft white pencil (optional)

Paper and board: Tracing paper, Cream mount (museum) board

Additional equipment: Pencil sharpener, Fine sandpaper (glass-paper) or emery board, Plastic eraser

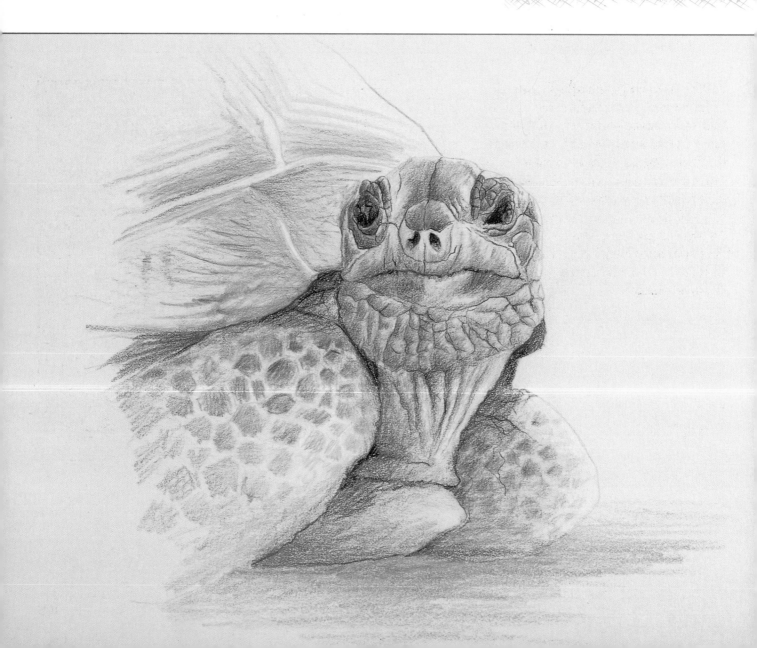

The support

There is a lot of pencil work involved in the burnishing technique, so the best surface to work on is mount (museum) board. A smooth, coloured paper can also be used, providing it is not too thin.

Reference photograph

In this photograph only the face and the nearest leg are in focus, so treat these as the main part of the picture with the most detail in, and fade off the rest of the tortoise.

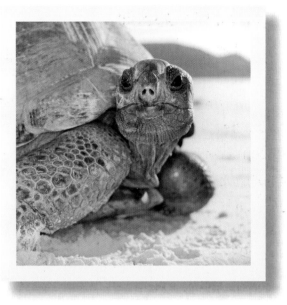

1 With the Burnishing technique (see page 18) it is important to remember not to put down too much colour, especially in the early stages. After tracing down or drawing the outline using light grey (French Grey 70), start to shade in the general areas of grey and yellow using the same light grey and a mid-tone yellow (Straw Yellow 5). There is no need to do any of the wrinkles and creases at this stage; they can be put in later. Next, start to shade in the darker patches with a bluer, darker grey (Blue Grey 68), leaving spaces for some of the brighter highlights.

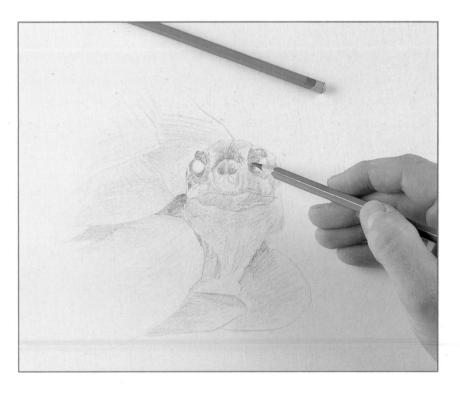

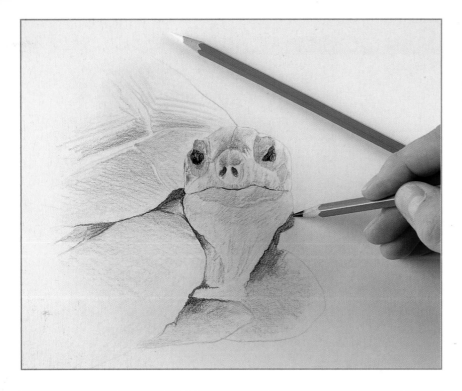

2 Using a black (Ivory Black 67) put in the eyes, nostrils and mouth line. Next, using the dark grey (Blue Grey 68) and applying more pressure, start to shade in some of the darker areas, varying the pressure in some places to achieve a lighter effect. Use white (Chinese White 72) to blend in the grey and yellow by rubbing over the colour you have already put down. (See Burnishing page 18.) If you lose some of the outlines put them back in when you have finished burnishing.

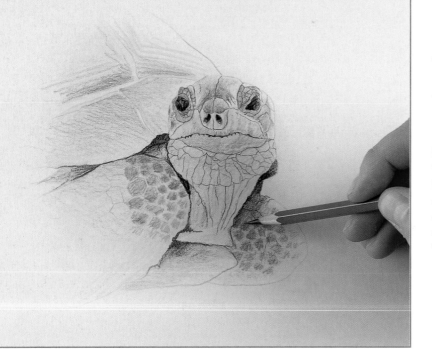

3 Using a sharp black pencil, start to draw in the lines of the wrinkles on the face and neck, paying particular attention to where the lines follow the contours of the face, especially around the eyes. Use a dark grey (Gunmetal 69) to start to shade in the hexagonal shapes on the legs, leaving a gap in between each one.

■ TIP: following the shape of the body

When drawing distinctive shapes and lines on objects, look long and hard at each line or shape, especially where it disappears around the edge of a leg or head. The shapes on the leg of the tortoise will get smaller and narrower the closer they are to the edge. It is little observations like these that turn an average drawing into a good one.

4 Although the head and legs are the important part of this picture, you will need to shade in the shell to balance the work done on the head. Using a dark green (Juniper Green 42) lightly shade in some parts of the smooth shell surface, shading in the direction of the curve of the shell. To achieve the smooth surface of the shell use the white to burnish over the colour and do the same to the grey shapes of the legs. This will soften some of the shading and help give the impression of leathery skin rather than fur. A softer white pencil can be used, but is not essential. Finally, go back over some of the darker areas with the grey pencils to redefine the edges.

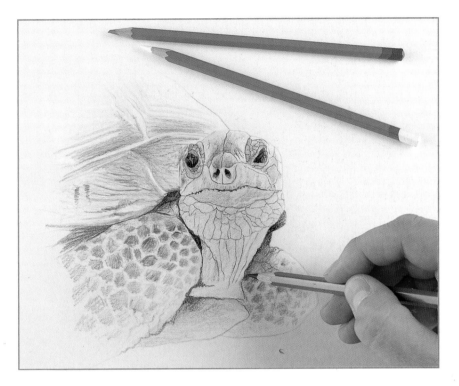

5 The mouth and chin area need to be yellowed slightly so, using a warm yellow (Gold 3) lightly shade in around the mouth line and down the chin. Next, using the blue grey (Blue Grey 68) darken some of the areas on the face, working around the lighter areas. Burnish these with the white and, finally, redefine the thin lines with the black.

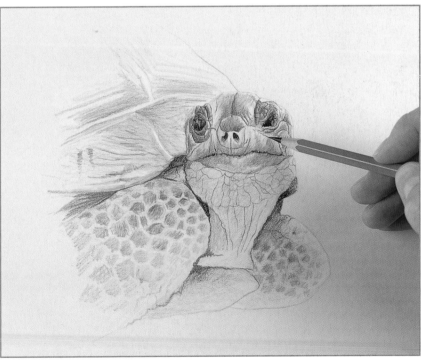

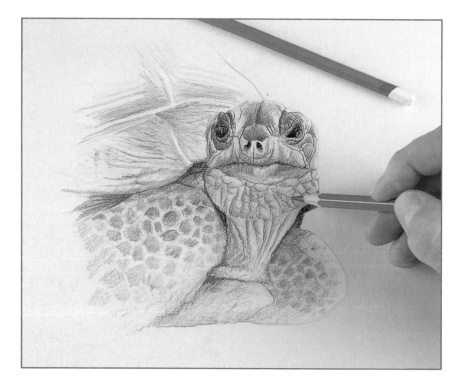

6 Using a dark grey (Gunmetal 69) shade in the left side of each wrinkle, leaving the right side as a highlight. This should give the impression of rounded wrinkles. When you have finished doing this, burnish each wrinkle with the white.

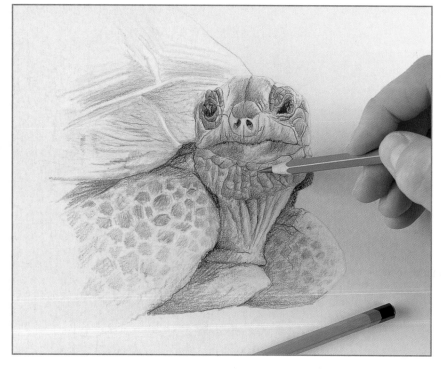

7 The dark grey used in the previous step has given a good basis to work on but will need to be darkened. Use a darker grey (Blue Grey 68) to repeat the shading technique on each wrinkle. Once you have done this, use the black to re-establish some of the wrinkle lines.

8 Finally, use a raw sienna (Raw Sienna 58) and light grey (French Grey 70) to shade in some of the sand that the tortoise is sitting on. Also shade in some raw sienna on the underside of the neck and chin.

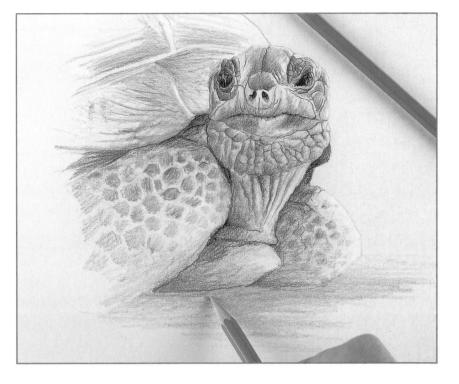

Technique check

This demonstration properly introduced you to the technique of burnishing to achieve a smooth surface. It is best carried out on a fairly rigid surface and uses white or other pale colours to rub and blend other colours together to achieve a smoother surface effect. Try doing a few exercises with different colours to see what can be achieved.

A step further: using experience and imagination

The demonstration will have given you an insight into what can be achieved by burnishing. The next step is to try something that encourages you to use your experience and, probably more importantly, your imagination. This particular photograph, for instance, is of two rhinos that have a similar skin texture to the tortoise of the main demonstration. However, the photograph was taken from further away and, consequently, features less skin detail. Use the same methods of shading

and burnishing to build up the skin tones and colour, before using black to put in the creases and wrinkles. Where you can't see any details use your imagination – in other words make them up – but remember that the lines of the creases and wrinkles will always follow the contours of the body.

ANIMALS

Cat portrait: painting technique

Most of the demonstrations so far have used the pencil dry. In this demonstration much of the colour will be applied using the pigment as paint and applying it with a brush. This will give a softer and more delicate feel to the finished picture.

MATERIALS

Pencils
Derwent watercolour pencils
 (used wet and dry):
Raw Sienna 58
Golden Brown 59
French Grey 70
Water Green 44
Copper Beech 61
Crimson Lake 20
Ivory Black 67
Deep Cadmium 6
Cedar Green 50
Gunmetal 69
Chinese White 72
Bronze 52
Burnt Sienna 62

Paint
Chinese White watercolour paint
 or white gouache (optional)

Paper
Tracing paper
White, not surface, 300gsm
 (140lb) watercolour paper

Additional equipment
Pencil sharpener
Fine sandpaper (glass-paper) or
 emery board
Putty eraser
Size 4 or 6 round watercolour
 brush
Jam jar
Tissues

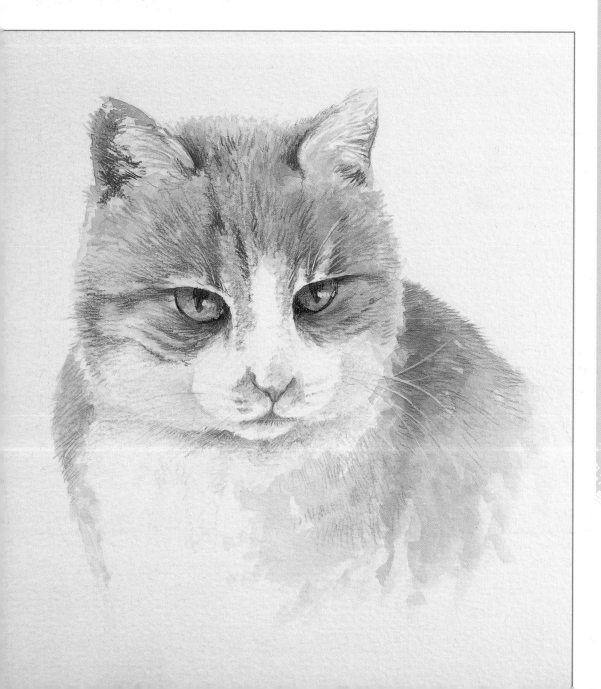

The support

You will be using quite a lot of water for this demonstration so you need a paper that is not too thin and so will not wrinkle when wet.

Reference photograph

When drawing pets or other animals you need to get up close, preferably head and shoulders, in order to get as much information out of the photograph as possible. The light and dark qualities in this photograph are not particularly good, so make the left side of the face lighter. Also, when photographs are taken of animals their eyes tend to darken; therefore when you draw the eyes try to put in lighter and brighter colours. You will also need to add highlights.

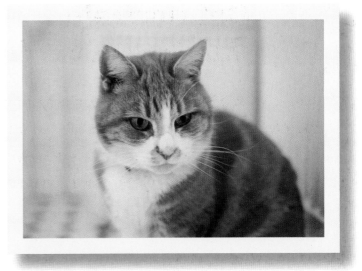

1 In Still life demonstation 4 (see pages 44–49) the colour was applied dry to the drawing then the shaded area was wetted with a damp brush. For this demonstration a palette of colours will be created on a scrap piece of watercolour paper and the colour applied wet. Draw or trace down a raw sienna (Raw Sienna 58) outline. Take Raw Sienna 58, Golden Brown 59 and French Grey 70 pencils and on a scrap sheet of watercolour paper shade a square of approximately 3cm (1½in) with each colour. You may want to write the name of each colour underneath each square. Using a size 4 or 6 round watercolour brush, wet the raw sienna square and start to shade in the brown areas on the cat's head and shoulders. Wet the golden brown square in the same way and use this to darken the initial wash where necessary. Use the grey in the same way to add shadow underneath the chin and around the jowls.

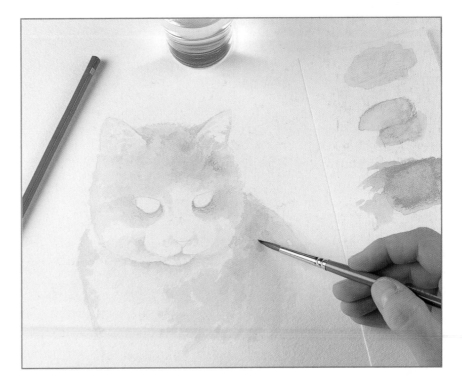

■ TIP: furry edges

The edge of the cat's head is not a solid, continuous line. So, when you come to paint the initial light brown wash, give the edge a furry look by flicking the point of the brush on the paper and away from the cat's head to give the impression of hairs and fur.

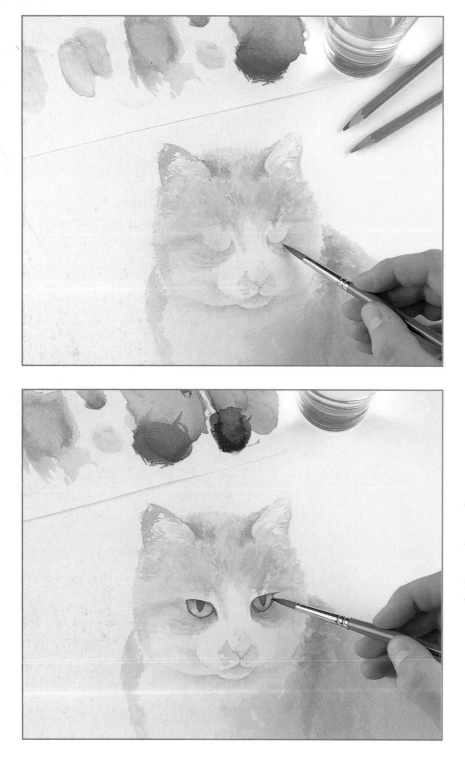

2 Continue to use the scrap paper as a paint palette. Pick up some light green (Water Green 44) on the brush and paint in the eyes. After cleaning the brush, mix one of the lighter browns used in Step 1 (Golden Brown 59) with a darker, richer brown (Copper Beech 61) on the scrap paper and start to build up the fur texture and warmth by flicking in the fur with the brush. The light is coming from the left so paint in the stronger mix of brown on the right side of the face and down the back. You can also start to edge the ears with the same colour. Put in a little light pink (Crimson Lake 20) on the nose and some of the light brown around the mouth area.

3 You cannot go any further with the fur until you have done some more work on the eyes. Using the brush, pick up some black (Ivory Black 67) and paint in the pupils and edges of the eyes. Next, using a warm yellow (Deep Cadmium 6), paint a wash of yellow over the green to warm it. When the yellow is dry, use a darker green (Cedar Green 50) to darken the edges of the eyeball where they are covered by the eyelids. Mix some of the black pigment in with some of the green on the scrap paper and use this to paint in the shadow of the upper eyelid and soften this off with a damp brush before it dries. Finally, go back over the pupils with the black.

4 The softness of the brushwork gives a good base to work on but does not give a sharp impression of the fur, so after the paint has dried on the paper start to put in the fur with dry pencils. Using a warm, yellow brown (Golden Brown 59) start to flick in the fur around the eyes, moving out from the eyes in the direction the fur is growing.

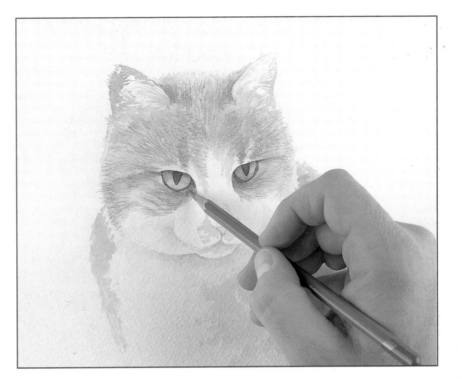

5 Use the warm grey (French Grey 70) to shade in the warm shadow areas around the jowls and mouth, and also under the chin. Use the same pencil to flick in a few grey hairs in the ears.

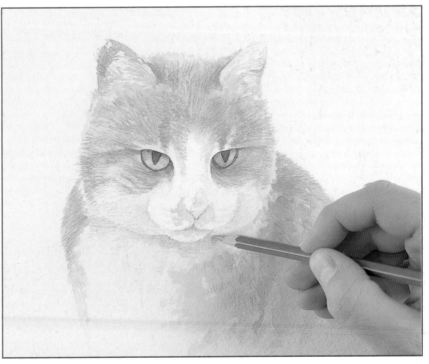

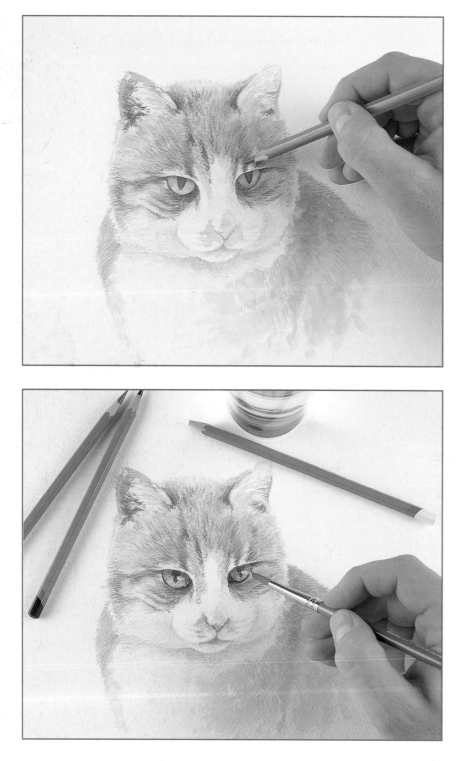

6 You can now start to build up the darker parts of the fur with a dark brown (Copper Beech 61). Using the same technique as in Step 4, flick around the eyes and move out in the direction the fur is growing.

7 Do some final work on the eyes and nose. Using a dry mid-tone grey (Gunmetal 69), shade lightly over the top of the eye where the eyelid throws a shadow. Next, using a wet brush, pick up some white pigment from the point of a white pencil (Chinese White 72) and carefully paint in some highlights. When this is dry you may need to darken the pupil with the black pencil. Finally, using dry warm brown (Bronze 52) and burnt sienna (Burnt Sienna 62), shade in around the nose and on the underneath of the pink nose itself.

8 Strengthen the underneath of the chin and mouth with a dry mid-tone grey (Gunmetal 69) and also around the jowls, because you need a certain amount of dark colour in these areas to show up the whiskers. To finish, use a wet brush to pick some white pigment from the end of the white pencil and paint in the whiskers. A white paint will be stronger and show up better against a pale background so could be used here instead.

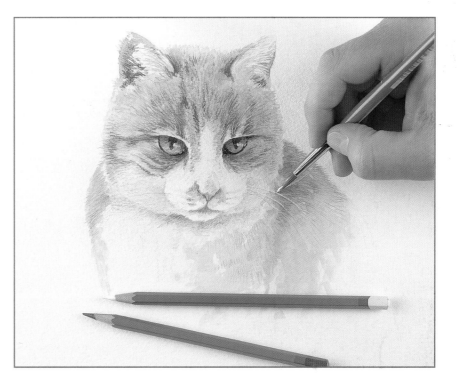

Technique check

Almost half of the colour in this picture was laid down as wet pigment. Using wet pigment is a quick way to get started and is particularly effective when depicting fur, as you have probably found out. This technique must be carried out on a watercolour paper, which is specially made to be painted on.

A step further: introducing a background

In some cases a picture of a particular animal, especially a wild animal, can be enhanced by the addition of a coloured background. In this instance the tiger is lying in a pool of water. Use the same techniques as described in Landscape demonstration 2 (see pages 56–61) to put in the water. Use horizontal pencil strokes to help give the impression of flat water. I recommend doing the background after you have done the drawing of the animal.

ANIMALS

Dog portrait:
drawing pet portraits

Most pet owners have numerous photographs of their pets, but there is something unique and special about having a drawing of your pet framed and hung on the wall. This demonstration shows you how to use the pencil line as a way of creating realistic fur using a simple sketching technique and, hopefully, will give you the confidence to do a picture of your own pet.

MATERIALS

Pencils
Derwent watercolour pencils
 (used dry):
Ivory Black 67
Chinese White 72
Light Blue 33
Burnt Umber 54
Brown Ochre 57
Gunmetal 69
Venetian Red 63
Chocolate 66
Copper Beech 61
French Grey 70

Soft white pencil (optional)

Paper and board
Tracing paper
Light brown mount (museum)
 board

Additional equipment
Pencil sharpener
Fine sandpaper (glass-paper) or
 emery board
Plastic eraser

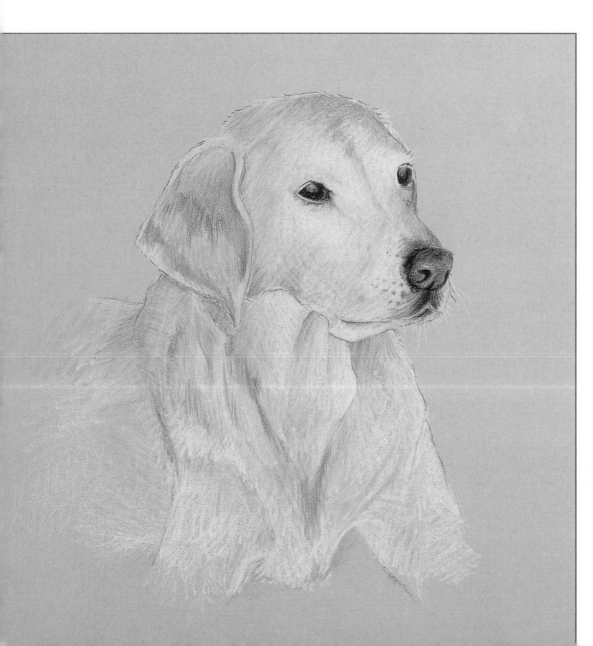

The support

A lot of light pencil colours are laid down in this demonstration so you need a support that can handle this amount of work. Mount (museum) board is ideal.

Reference photograph

The only thing that needs to be done to this picture is to crop the left and right side to create a portrait shape. The main emphasis in the picture will be on the head area, so there is no need to include any background detail.

1 The best way to achieve a likeness is to use the Tracing down method (see page 18), here done lightly in black (Ivory Black 67). Use white (Chinese White 72) to draw back over the outline, using the flicking technique with the sharpened point of the pencil to create a furry edge. (See Animals demonstration 1 pages 98–103.) Next, start on the eyes. Using a light blue (Light Blue 33) put in a small blue reflection in each eye. Then with a dark brown (Burnt Umber 54) fill in the whole of the eye except the blue highlight. Dogs do have white eyeballs but normally you can't see them because they are covered by the eyelids. Go back over the eye with black to put in the shadow where the eyelid covers the eyeball. Start to fill in the light fur areas with white. You may need to use a softer white pencil to build up the very white areas.

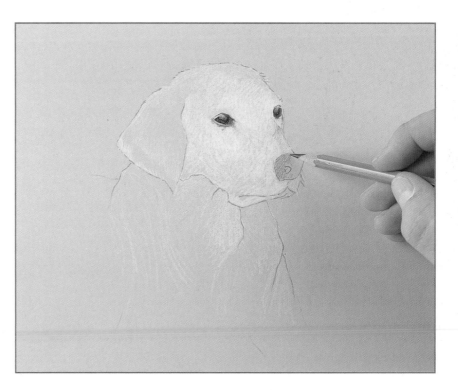

■ TIP: furry texture

A furry texture can be suggested by cross-hatching pencil lines. As you work over the furry areas try not to fill in too many flat areas of colour. Sharpen your pencil on the fine sandpaper (glass-paper) or an emery board to maintain a good point.

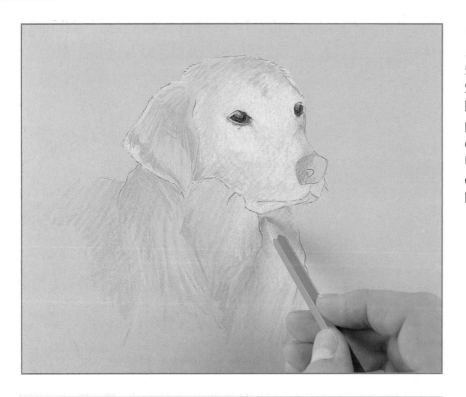

2 At the moment the picture looks pale, so warm up the fur with a light brown (Brown Ochre 57). Using the same technique as with the white in Step 1, start to shade over the white with the light brown, but only in the areas you can see in the photograph. Having done this you may need to define the outline a little. Use a dark brown (Burnt Umber 54) to flick in a few dark hairs around the edge of the head. Do not use the pencil too heavily because this will give the picture a cartoon look.

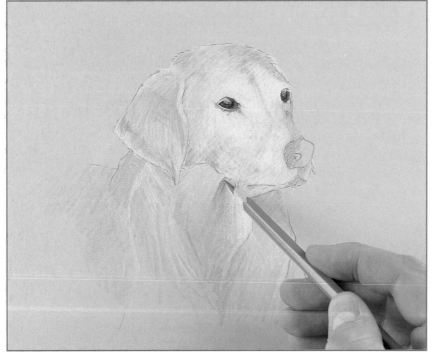

3 Now it is time to concentrate on the shadow parts of the white fur. Using a dark grey (Gunmetal 69), shade in over the white fur and start to develop the bridge of the nose and the mouth area. You will need to choose a darker grey than appears in the reference photograph because the white that you have already put down will make the grey look lighter.

■ **TIP: white and grey**
If you are not sure what the combination of white and grey will look like then practise on the corner of your support before committing to your drawing.

4 Before you start to build up the rest of the head and body, the nose needs to be finished. Choose a red brown (Venetian Red 63) to shade in the basic colour of the nose and a darker brown (Chocolate 66) to darken the edge and the surrounding area of the face to give the impression that the nose is growing out of the face rather than being stuck on. Next, using the white, burnish over the red of the nose and, pressing a little harder, put in the highlights around the nostril. (See Burnishing page 18.) Put in the dark of the nostril with a little black.

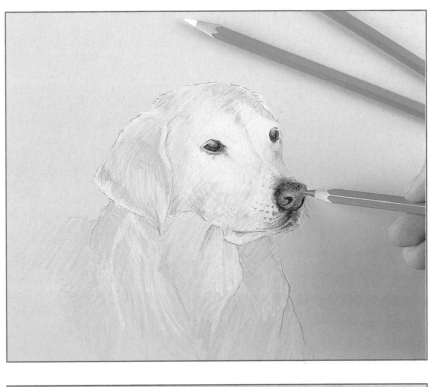

5 Start to build up the darker parts of the fur with a mid-tone warm brown (Copper Beech 61) especially on the ears and lower body under the chin. Try to maintain the fur texture by using the flicking technique.

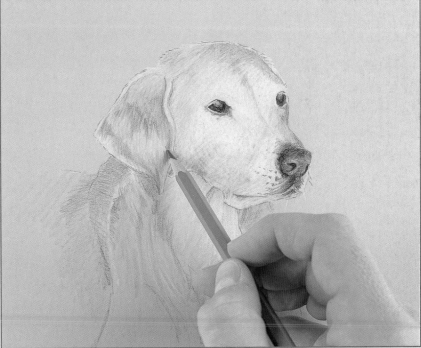

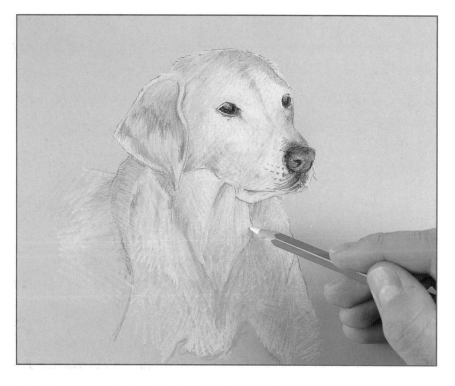

6 Move down to the body of the dog and fill in the fur with the white pencil. The head is the important part of the drawing so there is no need to put as much fur detail in the body, instead use a rough, cross-hatching technique to suggest the texture.

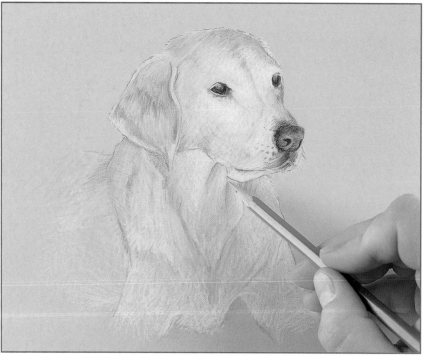

7 Before moving on to the final parts of the picture, shade in some of the more subtle areas of grey fur. Choose a light, warm grey (French Grey 70) for this and shade in around the face and down, across the body.

8 Use a light brown (Brown Ochre 57) to put some of the warm fur back in that you lost when using the white. Next, use a sharp black pencil to strengthen the eyes and nose and, finally, use a sharp white to put in some hairs and whiskers that are sticking out from the side of the face and chin.

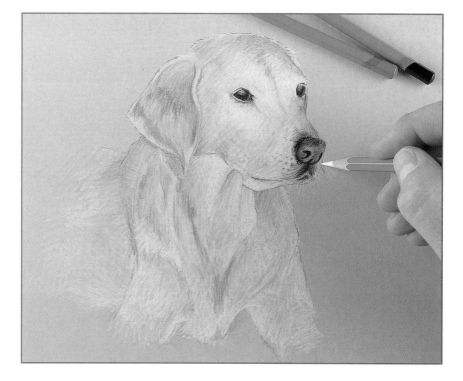

Technique check

This demonstration has shown you how to draw pet portraits and how to achieve fur textures using a sketching and cross-hatching technique. Probably the most important part of the demonstration was the reference photograph. If you are going to draw your own pet make sure you get a photograph from as close as possible to help with the detail and give you a better chance of getting the likeness right. Take as many photographs as possible from different angles, outside as well as in.

A step further: long white hair

The dog in the demonstration photograph had very short hair that is relatively easy to achieve using the flicking technique. This photograph, however, features a dog with long white hair, the drawing of which requires a different and altogether more challenging technique. First of all you need to choose a coloured back-ground to work on. Something like this is virtually impossible on a white background, so choose a colour that is close to the colour of the sandy beach that the dog is sitting on. When drawing the fur, start with a soft white pencil and work the pencil lines in the same direction as the

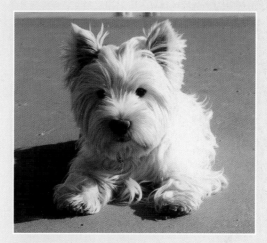

fur. This is a good-quality photograph so it is easy to see the way the fur moves around the face and feet. Once you have done the white fur you can start to use some light and dark greys to fill in some of the darker areas. Try looking at the spaces in between the hairs rather than the hairs themselves.

Gallery

These gallery pages show examples of work produced by some top coloured pencil artists. There is a short description underneath each picture explaining the thought process and material used in the production of the drawing.

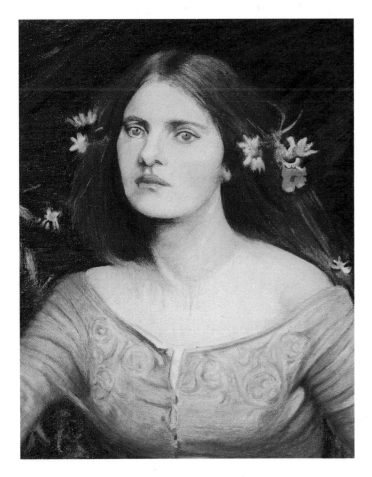

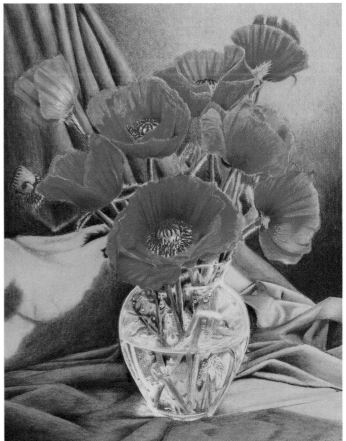

Ophelia after J. W. Waterhouse, 1849–1917
16 x 13cm (6¼ x 5⅛in)
By Bob Ebdon

Paintings by old masters are a good source of reference without the copyright issues usually involved in using other people's work, providing you mention the original artist's name in the title, as the artist has done here. This particular drawing has the appearance of being a life-size portrait, yet it is in fact particularly small. The artist says that he surprised himself with what he achieved, and I can understand why. The drawing was done with Karisma (Prismacolor) pencils on a paper called Rising Stonehenge that is similar to smooth watercolour paper.

Poppies
25 x 20cm (9¾ x 8in)
By Bob Ebdon

What is striking about this picture is the depth of colour that the artist has achieved, in particular the reds and greens on a white paper support. The depiction of a glass vase is also stunning. The artist describes this as one of his best works to date: "It is a mixture of pencils, with Karisma supplying the reds and Derwent and Faber Castell the greens. The support is Rising Stonehenge. I was pleased with the detail I got, especially in the vase. There is, roughly, 25 hours of work here."

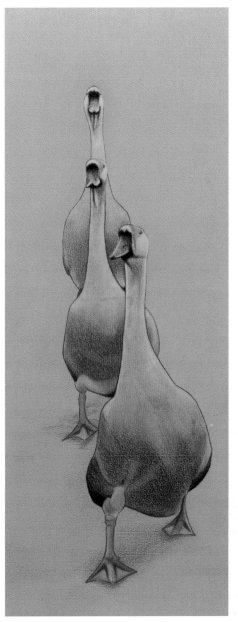

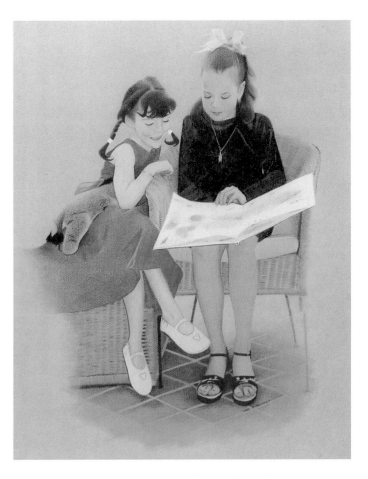

Cara and Kaley *Collection of Carlton and Teresa Ainsworth*
63 x 56cm (25 x 22in)
By Gary Theobald

When I first saw this picture I thought it had been done on a light purple paper but, as Gary explains, appearances can be deceptive: "This commissioned piece was based on a selection of photographs taken of the girls at home. Working on a grey brown sheet of pastel paper (smooth side) I decided to fade the edges of the piece and introduce a complementary colour theme to the background to avoid distracting the viewer from the prime subject, being of course the girls."

Goose Step
46 x 30cm (18 x 12in)
By Gary Theobald

This is a good example of how not all pictures need to be a serious representation of the subject. They can be fun too. Gary explains that this was done from a selection of photographs: "This piece was inspired and composed from several photographs of parkland geese. I decided to have three birds in a line heading towards the viewer. Working on a pale yellow pastel paper (smooth side) and using shades of orange and burnt carmine from the Derwent range of pencils, I made subtle changes to the background and created shadows on the floor. Using layering and burnishing techniques the geese were created in an animated style."

Gallery

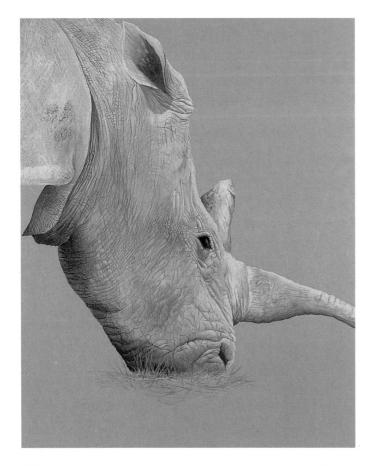

Rhino
40 x 26cm (15¾ x 10¼in)
By Jonathan Newey

This is a study of the head of a white rhino from a photograph taken on a visit to a wildlife park. It was done using Karisma (Prismacolor) pencils dry on a dark grey mount (museum) board. The photograph itself was slightly out of focus so imagination and experience were employed to fill in many of the wrinkles. Most of the colours used are white, black and a variety of greys. There would seem to be a lot of work involved in this picture but in fact the colour of the mount board contributes a certain amount of grey to the overall picture. Note how the wrinkles and creases follow the contours of the head.

One foot in the grave
27 x 40cm (10½ x 15¾in)
By Jonathan Newey

This study of a tortoise is similar to the one in Animals demonstration 2 (see pages 104–109) and used the same tools and materials. Most of the work has been done in the head, neck and leg areas, leaving the rest of the picture fairly light and sketchy. The edge of the shell at the top is very light but your eye automatically puts a heavier line in. There was a lot of burnishing involved in this picture, which contributed to it taking about 20 hours to complete.

My sweet lolly
23 x 19cm (9 x 7½ in)
By Maddy Swan

This wonderful drawing is in fact a self-portrait done by the artist from a black-and-white photograph. The use of a limited palette of colours is particularly effective. The artist has used similar colours in the face and in the drawing of the dress, and says that the reference photograph was always a favourite of hers, but there was a disagreement over the colour of the dress: "My brother and I had a minor dispute over the colour of the dress. He insisted that the flowers should have been blue instead of red. Our mother came to my rescue and produced the original dress as evidence, which she had lovingly kept, and to my delight, I was proved right."

Furry friends
25 x 18cm (10 x 7 in)
By Maddy Swan

Sometimes the choice of background or surroundings can be just as important as the subject itself. In this picture of her son, the artist has used a window as a light source: "I like this picture very much because of the special quality of the light pouring in from the window and the lovely shadows that the light creates. Alex used to have long conversations with his furry animals, hence the title."

Index

Acknowledgements

I would like to thank all the people who have helped and supported me in producing this, my first book. To everybody at New Holland Publishers, particularly Clare Hubbard for all the help and guidance she has given to me, and to Tony Paul who suggested I do this in the first place. To Shona Wood for producing the wonderful photographs in this book and to all the editors, designers and manufacturers who put it all together.

Many thanks also go to the members of the UK Coloured Pencil Society (www.ukcps.co.uk) whose continued work in promoting the coloured pencil as a serious drawing medium has increased people's awareness of what can be achieved. Special thanks go to Bob Ebdon, Gary Theobald, Graham Brace and Maddy Swan for the use of their pictures. Keep up the good work.

Thank you to Richard Cartwright of West Norfolk Arts Centre (www.westnorfolkarts.co.uk) for the wonderful things said in the foreword and to all my students over the years whose enthusiasm and praise have kept me going. Thanks also go to The Cumberland Pencil Company (www.pencils.co.uk) whose Derwent Watercolour Pencils I have used throughout this book.

And finally thanks to my family for being the subjects in some of the demonstrations in this book and for their help and support over the years. I could not have done this without you.

31901046941516